Remembering
West Point

Eugene J. Palka and Jon C. Malinowski

TURNER
PUBLISHING COMPANY

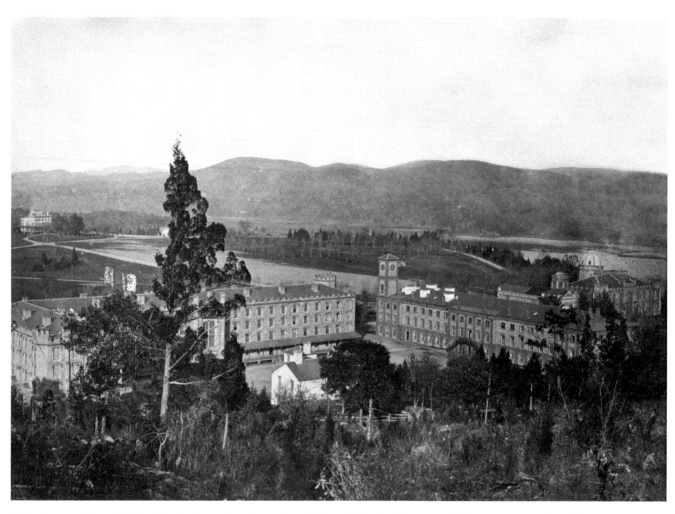

This photograph, probably taken in the 1860s, shows the old barracks in the foreground. These were completed between 1849 and 1851. To the right is the old academic building, identifiable by its clock tower. It occupied the site from 1838 to 1891. Behind it can be seen the top of the Old Cadet Chapel and the old library building. At top-left is the West Point Hotel, built in 1829.

Remembering
West Point

Turner Publishing Company
4507 Charlotte Avenue • Suite 100
Nashville, Tennessee 37209
(615) 255-2665

Remembering West Point

www.turnerpublishing.com

Library of Congress Control Number: 2010924326

ISBN: 978-1-59652-672-3

Printed in the United States of America

ISBN: 978-1-68336-905-9 (pbk)

CONTENTS

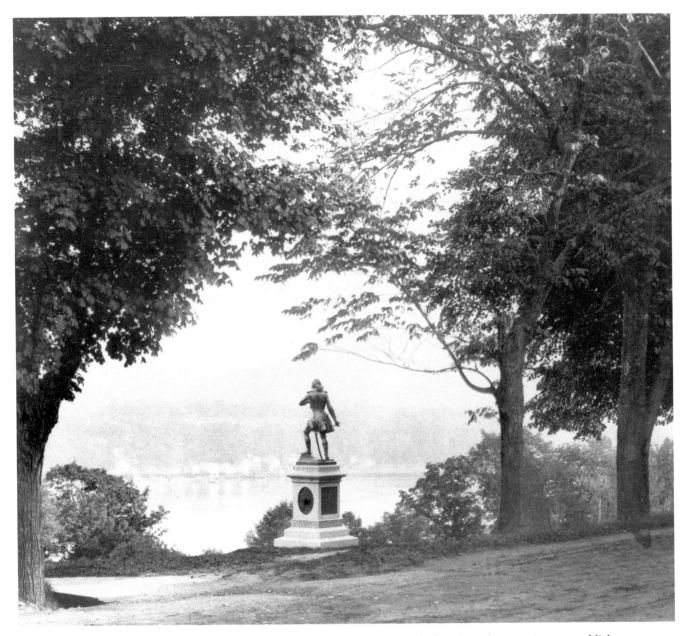

This statue of General George Armstrong Custer, erected at West Point in 1879 before Custer's reputation was publicly controversial, was so hated by his wife that she persuaded officials to remove it in 1884. The monument, with an obelisk replacing the statue, was moved to the cemetery, where it still stands.

ACKNOWLEDGMENTS

This volume, *Remembering West Point,* is the result of the cooperation and efforts of many individuals and organizations. It is with great thanks that we acknowledge the valuable contribution of the following for their generous support:

Library of Congress
National Archives
United States Military Academy at West Point

The writers appreciate the continuing support of their families and friends and are also grateful to the men and women of the Corps of Cadets who have inspired them over the years.

PREFACE

The United States Military Academy was founded by an Act of Congress on March 16, 1802, on the hallowed grounds of West Point, an Army fort located on the west bank of the Hudson River, about 50 miles north of New York City. Constructed and fortified as an integral part of the Colonials' defensive strategy during the early years of the American Revolutionary War, West Point is the longest continuously occupied Army post in the United States. Meanwhile, the military academy and its graduates have become synonymous with leadership, professionalism, and service to the nation. Indeed, the Academy's motto of "duty, honor, and country" continues to function as a guidepost for cadets, staff, faculty, and graduates, and serves as inspiration for the American public.

Each year this National Historic Site and home of the United States Corps of Cadets attracts more than three million visitors. Tourists attend cadet activities, parades, special lectures, concerts, and sporting events. Many choose a guided tour of the Academy grounds, and devote extra attention to the numerous monuments, remaining fortifications, and landscape architecture. Of course, recent visitors can only imagine the past, while focusing on aspects of the current cultural landscape. The West Point of today actually comprises a series of human imprints that have been superposed on this natural setting continually since the first inhabitants of the Hudson Valley set foot in this area. Some of the additions or changes to the Academy or reservation landscape are relatively new or ongoing at this time, and are very pronounced (such as the Jefferson Library). Other modifications or additions date back to the earliest days of the American Revolution. Some of these historic additions are quite noticeable (such as the Commandant's quarters, circa 1819), while others are more subtle or blend so well with the architectural scheme that their age is difficult to determine. For those who have the time and patience to sort through it, the juxtaposition of historic structures makes for an impressive and aesthetically pleasing, if not historically revealing, landscape.

West Point's magnificent natural setting and built environment meld to produce a picturesque landscape that has been the object of countless paintings and photographs. Although the architectural design of the

buildings provides a sense of rich history, tradition, and permanence, the military academy has continued to evolve for more than 205 years. The historic photographs featured within this book provide testament to the many changes that have occurred over time, yet enable the reader to appreciate some of the enduring aspects of this national treasure.

Our intent is not to chronicle the history of the U.S. Military Academy or West Point, but to illuminate four eras of development by way of examining historic photos contained within the National Archives and other special collections. The delineation and designation of any formative periods might prompt debate, but our organization has certainly not been arbitrary. We have chosen to step beyond the first half century, which has been chronicled elsewhere, and have stopped short of the most recent era, which is still unfolding. Thus, our historical portfolio stretches from the 1860s to the period after World War II.

The first era spans the 1860s to 1899, highlighting the Civil War as the chief catalyst for change. The second extends from 1900 to 1918 and features the impact of West Point's architectural revolution, as well as World War I. The third era ranges from 1919 to 1939 and captures the essence of life at the Academy during the interwar years, while elaborating on the significant changes ushered in by Superintendent Douglas MacArthur during the early 1920s. The last period covers 1940–1952, an era when West Point felt the impacts of World War II and the conflict in Korea.

We have tried to achieve a sense of balance with our selection of photographs and descriptions, employing historic photos and interesting anecdotes to enhance one's understanding of how the U.S. Military Academy and West Point have continued to evolve through the ages. If we have enabled a small segment of the American public to better connect with one of the nation's treasures and appreciate some aspects of its celebrated history, then we have succeeded in our purpose.

—*Eugene J. Palka & Jon C. Malinowski*

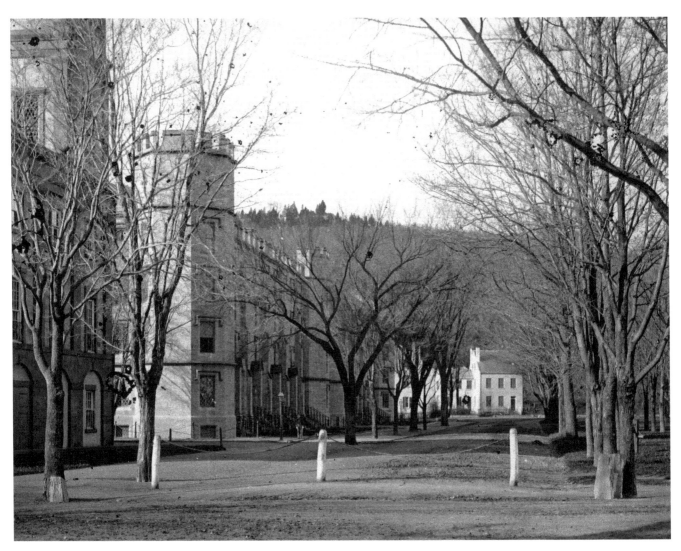

Probably taken in the 1860s or 1870s, this photograph shows the front of cadet barracks, built 1849-51. The tower with the castellated top and a small part of these barracks remains today as the Old First Division Building and houses the Cadet Honor Committee.

Civil War and Social Change

(1860s–1899)

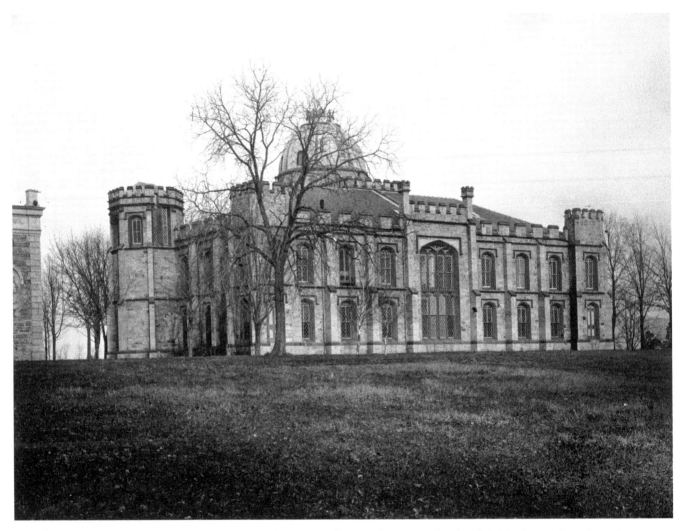

This library building was constructed in 1841 and shows the influence of Major Richard Delafield's time as Superintendent. Delafield favored buildings in what is sometimes referred to as Tudor-Gothic, with features reminiscent of castles, such as towers, Gothic (pointed) arches, crenellations, and dripstones over the windows. This picture shows the back of the Library, which stood on the Plain until 1961.

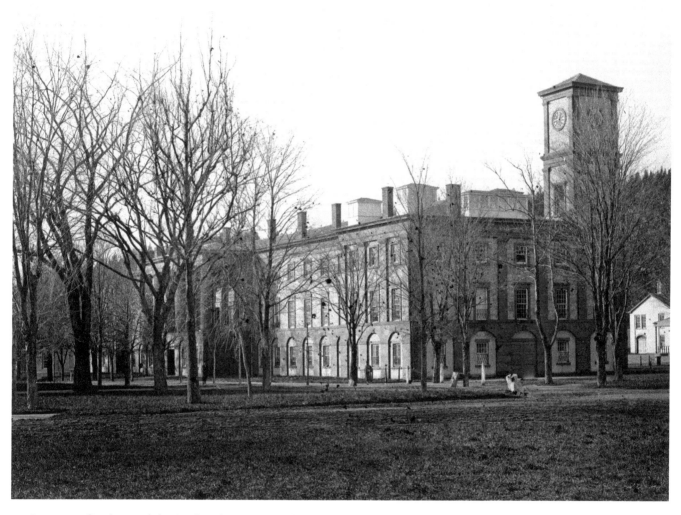

In 1838, a fire damaged the Academy's primary academic building, allowing for the construction of a larger academic building, pictured here. The building was stone and stucco and had both Italianate features, such as the rounded arches, and Greek features, such as Doric columns. It was in use until 1891, when it was replaced with what is now known as Pershing Hall.

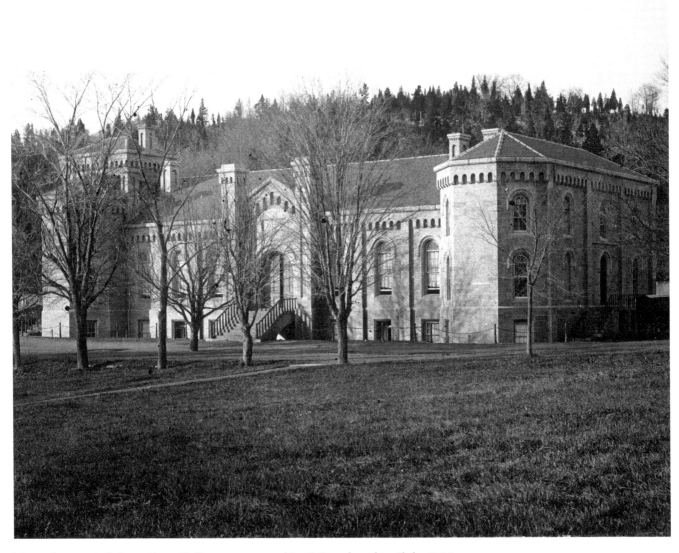

The cadet mess hall (later Grant Hall) was constructed in 1852 and used until the 1920s.

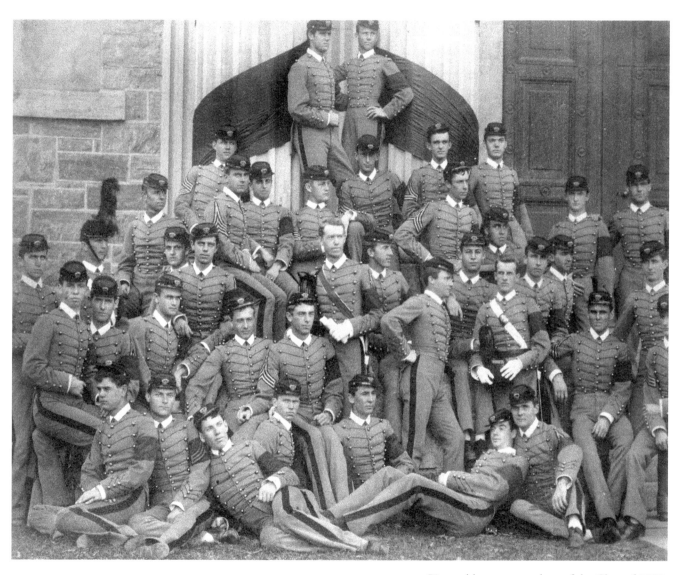

Pictured here are members of the Class of 1882.

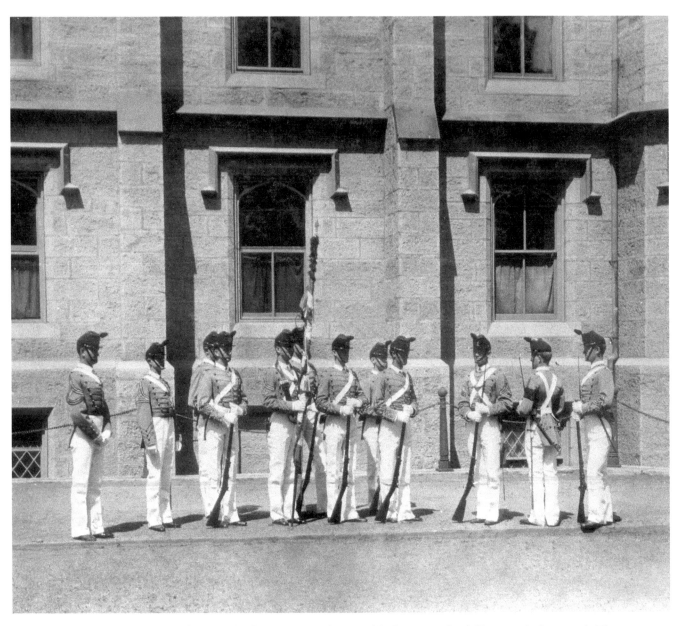

Wearing "full-dress over white, under arms," cadets anticipate the assembly formation for drill or parade (ca. 1883). The cap worn with the full dress uniform was called a "shako," but has long been referred to as a "tarbucket" in cadet slang. The barracks are in the background.

This panorama, possibly taken from Fort Putnam, shows the Academy area in what appears to be the 1890s. The most visible building is the West Academic Building, now known as Pershing Hall, which was constructed between 1891 and 1895.

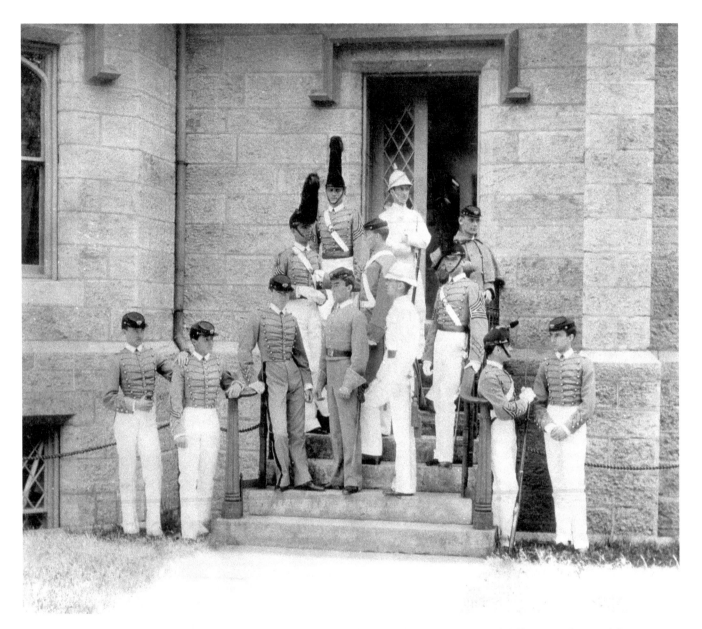

Congregating on the "stoops" of the barracks, cadets in this 1883 photograph feature a range of different uniforms of the era. Included here are full dress over white, dress white, full dress over gray, and the field uniform. Cadets adorned with a cross belt are under arms with rifle (second from right), while those with single diagonal belts are wearing sabers (upper left). One cadet is sporting his long overcoat with the cape folded back (upper right).

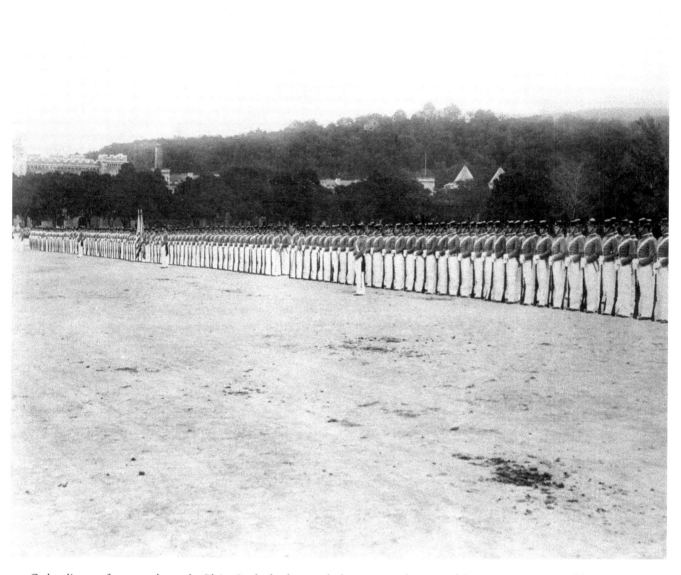

Cadets line up for a parade on the Plain. In the background, the two coned towers of the gymnasium are visible on the right. It was constructed in 1891. In the far left, the castlelike top of the West Academic Building is visible.

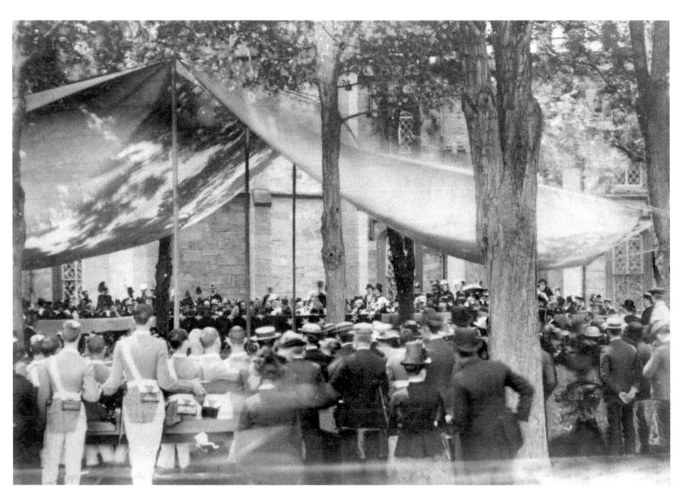

Cadets, officers, and guests gather for graduation day festivities on June 12, 1886, next to the Library. The graduates, including John J. Pershing, listened to a long speech by Civil War and Indian War veteran John Gibbon.

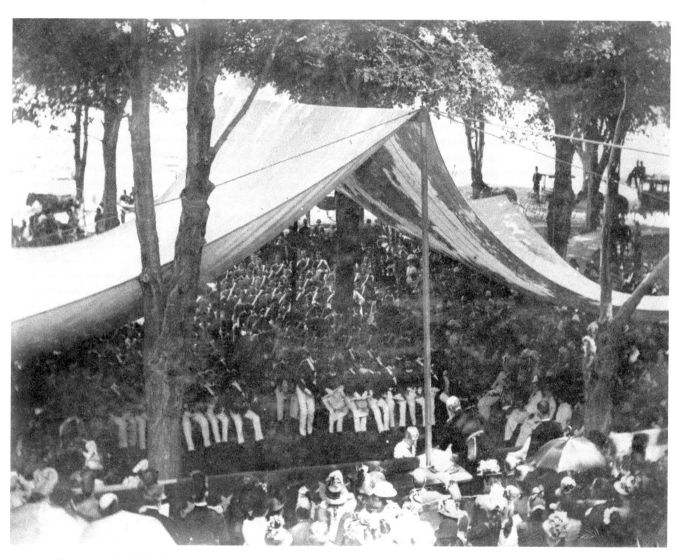

A large tent shields ladies and graduating cadets from the hot sun on June 11, 1888. New England–born Henry Flanders, a Philadelphia lawyer and member of the Board of Visitors, addressed the graduates. The class included Peyton Conway March, who would later become Army Chief of Staff in 1918.

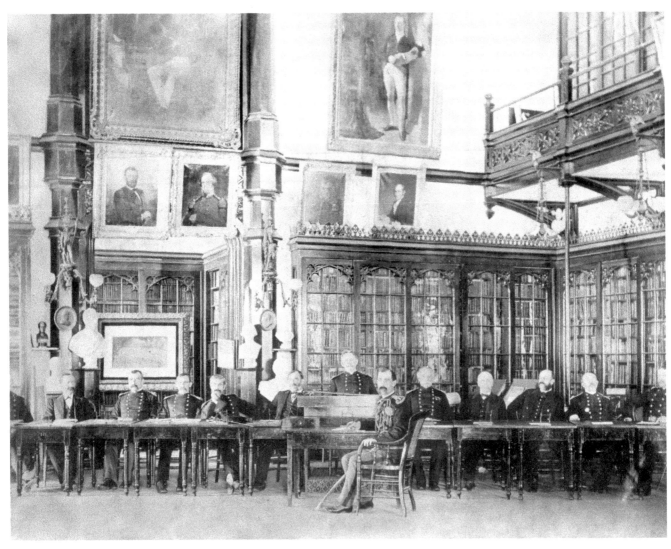

The Academic Board, consisting primarily of the Academy's department heads, pose together around 1886 in the Library.

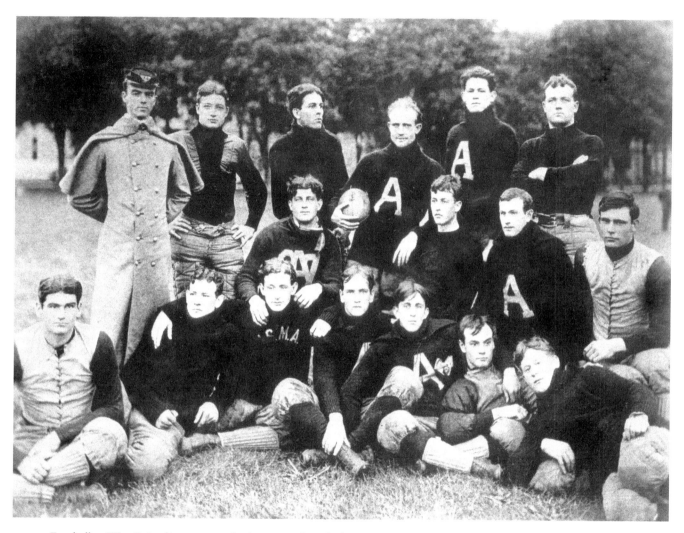

Football at West Point became popular in 1890 when Cadet Dennis Mahan Michie helped to organize the first Army-Navy game. Played on the Plain at West Point, the Midshipmen won the first encounter 24–0. This photograph features the Army team of 1896.

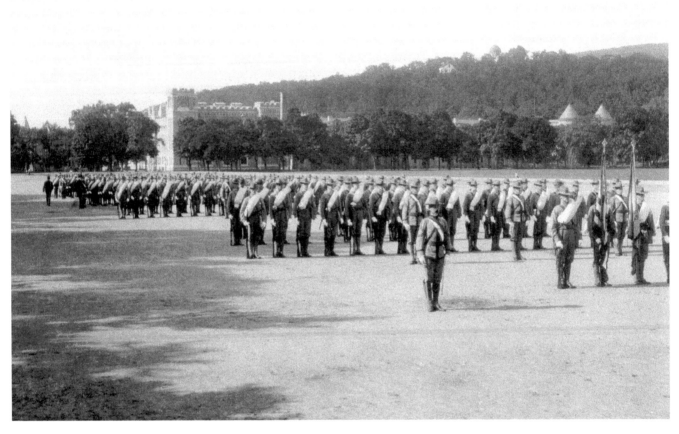

The Class of 1899 included this photograph of a formation on the Plain in their class album. The cadets appear to be carrying bedrolls.

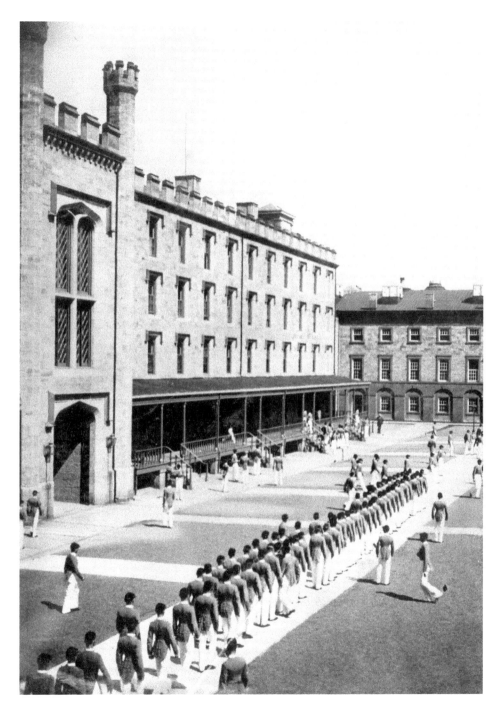

This photograph, taken prior to 1891, shows cadets marching to dinner.

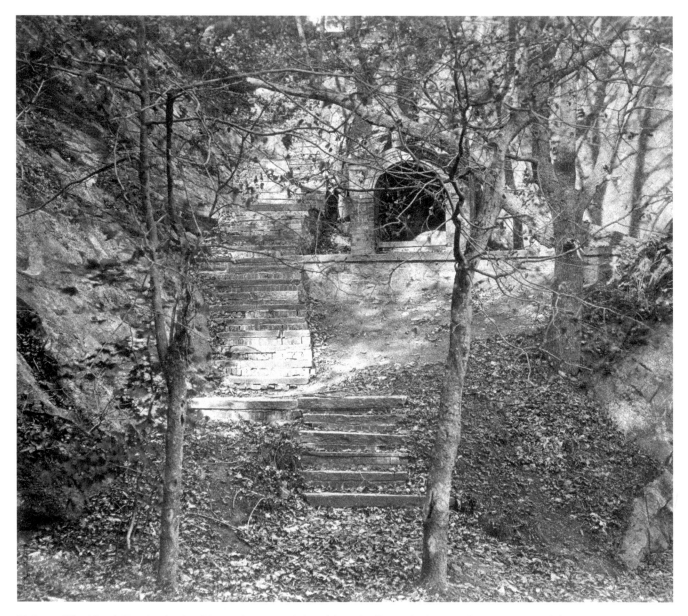

Tadeusz (Thaddeus) Kosciuszko (1746–1817) was a Polish noble and officer who became head engineer of the Continental Army during the American Revolution. One of his many contributions to the American cause was overseeing the construction of fortifications at West Point. Pictured here is Kosciuszko's Garden, the place where the Polish patriot is said to have sought refuge from the pressures of the day. The photograph likely dates from the 1880s.

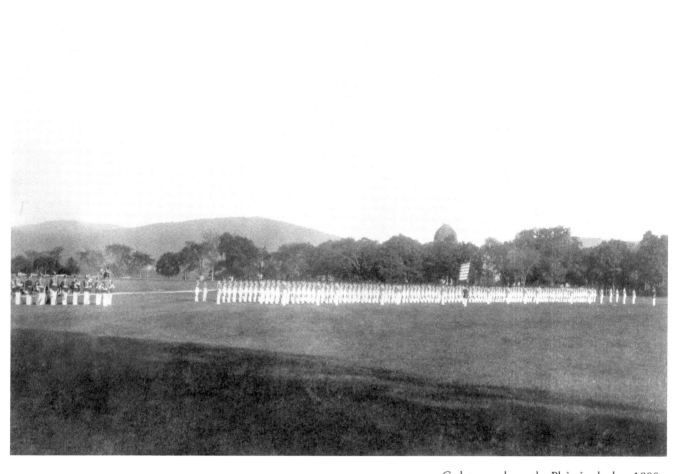

Cadets parade on the Plain in the late 1800s.

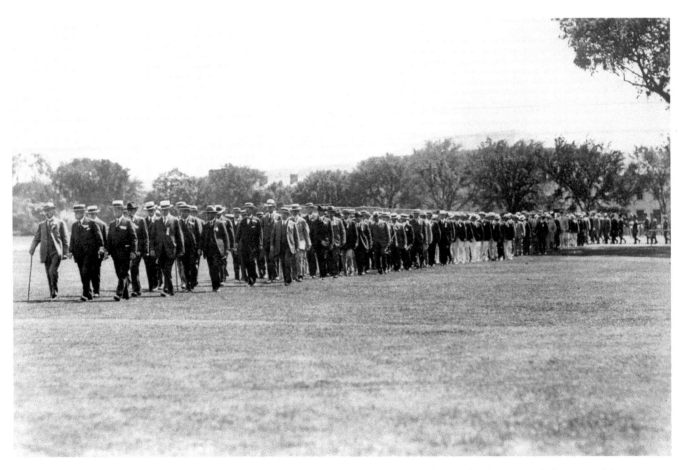

Alumni reunions are a common occurrence at West Point. This alumni gathering likely took place around the turn of the century.

DECADES OF CHANGE

(1900–1918)

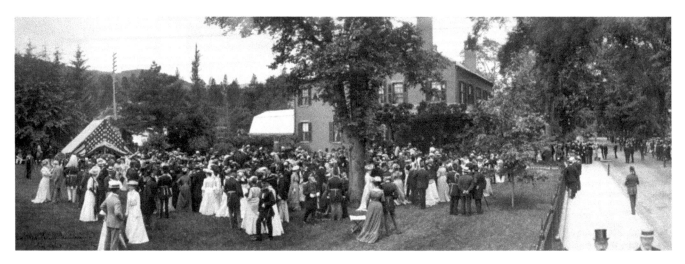

In June of 1902 the Academy celebrated its centennial with a presidential visit. This photograph is thought to show the reception hosted at the Superintendent's house for President Theodore Roosevelt on June 11.

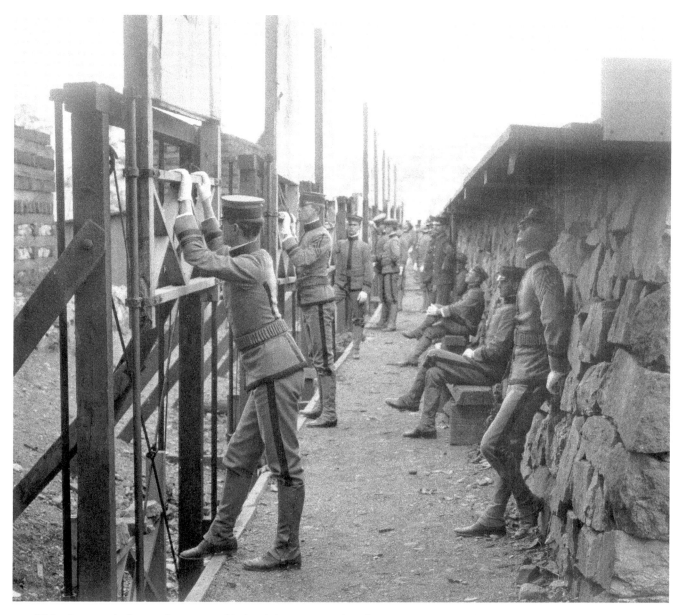

This photograph shows what occurred behind the scenes at the rifle range in 1903. Cadets in the picture constitute the "target detail." Protected by "butts," the cadets in the trench raise, lower, mark, and count the bullet holes in the targets after each firing order. The sounds of the bullets passing overhead were undoubtedly intriguing, at least to those who were working in the trench for the first time.

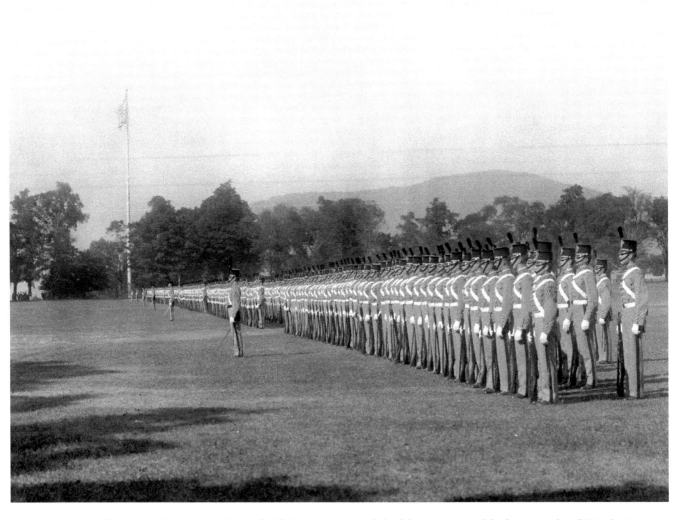

As cadets stand in formation during a parade on the Plain, one is reminded of the expression, "the long gray line." Trophy Point is located in the background and includes the flagpole on the left and Battle Monument on the right. Cadets are wearing full dress uniforms with seasonal gray trousers (ca. 1903).

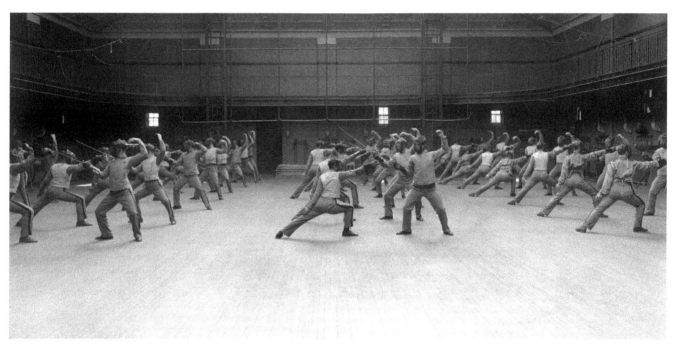

Cadets participate in fencing class as part of their physical development program around 1903. Although fencing is no longer a required course within the physical fitness curriculum, the U.S. Military Academy still has competitive men's and women's fencing teams. Both have won intercollegiate club championships in recent years.

Douglas MacArthur graduated first in the Class of 1903. Sixteen years later, he would return to oversee the Academy as its Superintendent (1919–1922).

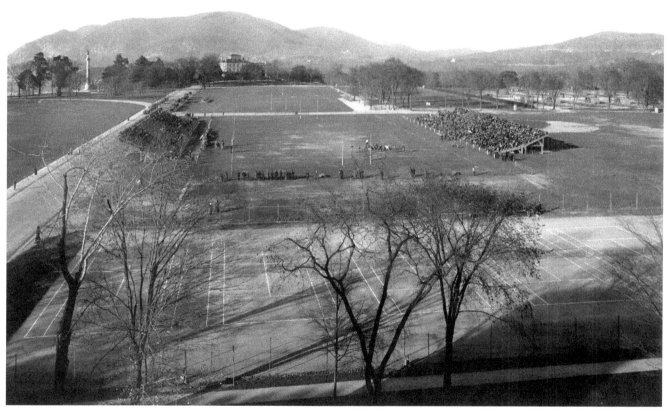

Army hosts a football game on the Plain in the early 1900s. In the distance is the West Point Hotel.

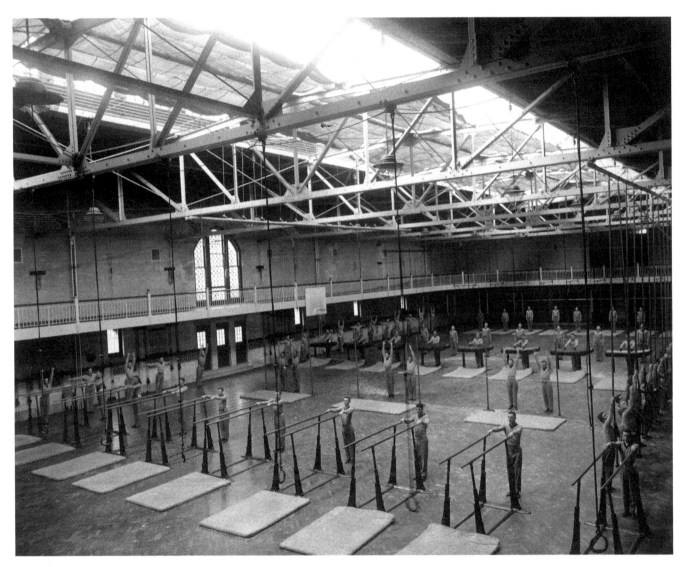

Gymnastics have long been a part of the physical fitness curriculum for all cadets, as shown in this image from 1903. Here in the gymnasium, cadets are introduced to the parallel bars, the vault, tumbling, the high bar, rings, and the ropes. The same types of exercise equipment and routines are an integral part of the current "military movement" class, although the facility, precise equipment, and gym uniforms have changed significantly.

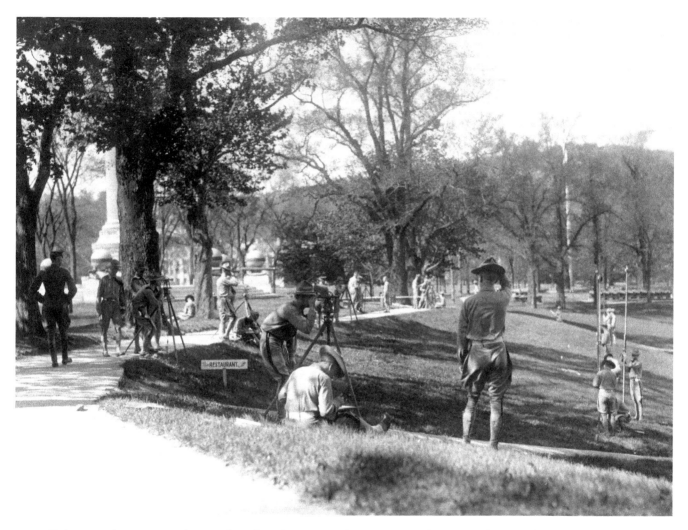

Cadets attend a surveying class conducted outdoors at Trophy Point, around 1903. At the time, the course was taught by the Department of Practical Military Engineering. This course continues to be offered within the Department of Geography and Environmental Engineering, and includes classroom lectures and practical exercises outdoors. Battle Monument is to the left and the flagpole is visible to the right.

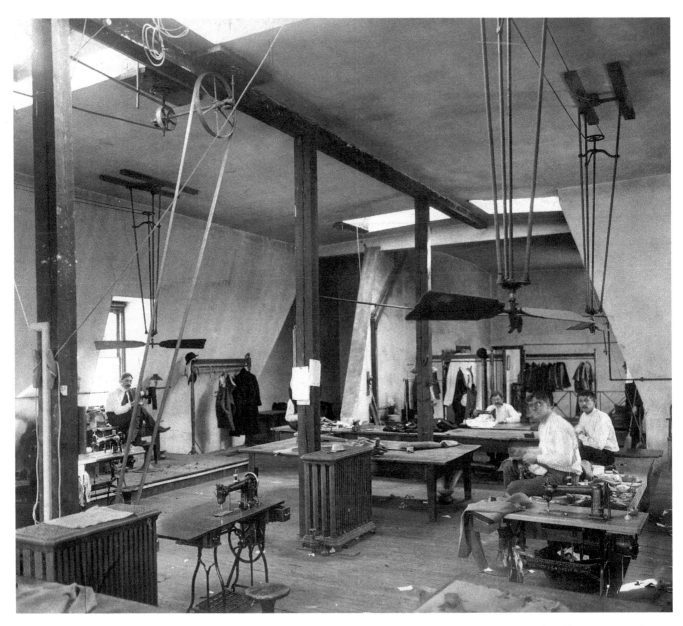

Since the founding of the Military Academy, cadets have always worn military uniforms of various types for all occasions: military training, academic classes, social events, and physical education. Tailors, such as those shown in this picture of the old cadet store from around 1903, are in steady demand throughout the year.

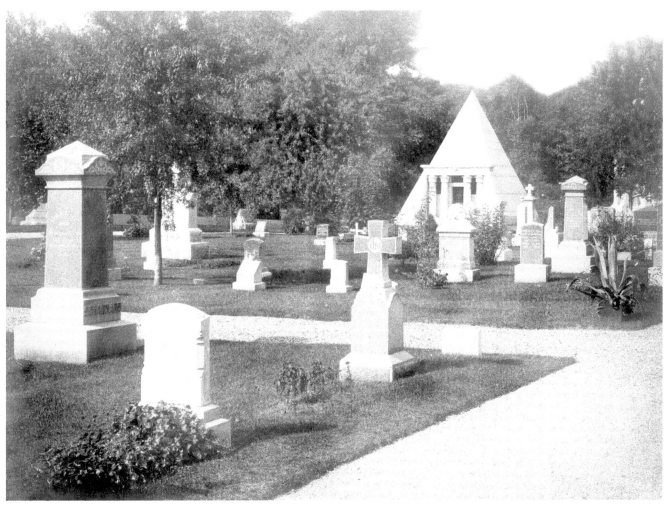

Egbert Viele's pyramid-shaped monument, shown here in 1903, is a standout of the West Point cemetery and reportedly was designed with a working buzzer to protect against his being buried alive. Viele graduated in 1847 and went on to serve in the Mexican-American War and Civil War. He was also engineer-in-chief of Central Park, a congressman, a businessman, and commissioner of parks for New York City. Viele died in 1902.

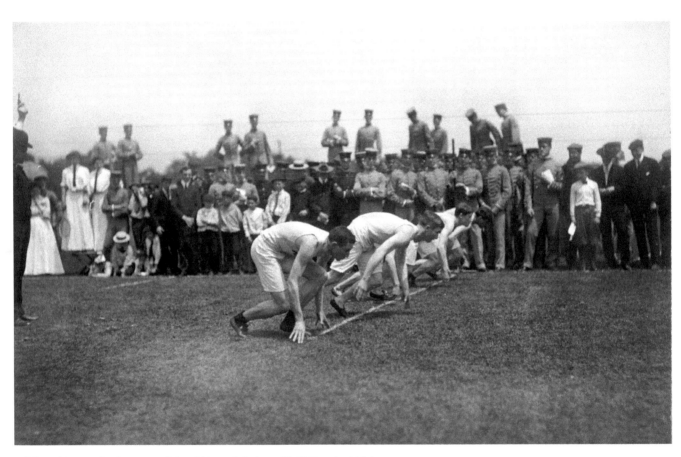

Athletes line up for the start of the 440-yard dash on Field Day in 1904.

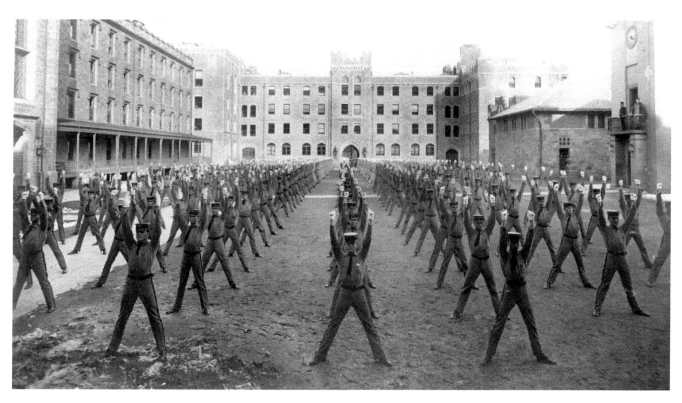

Cadets do calisthenics on a late winter day in 1904. From left to right, the buildings visible include the cadet barracks, the West Academic Building (now Pershing Hall), a utility building that housed steam boilers and the showers, and the Commandant's office (far right with clock).

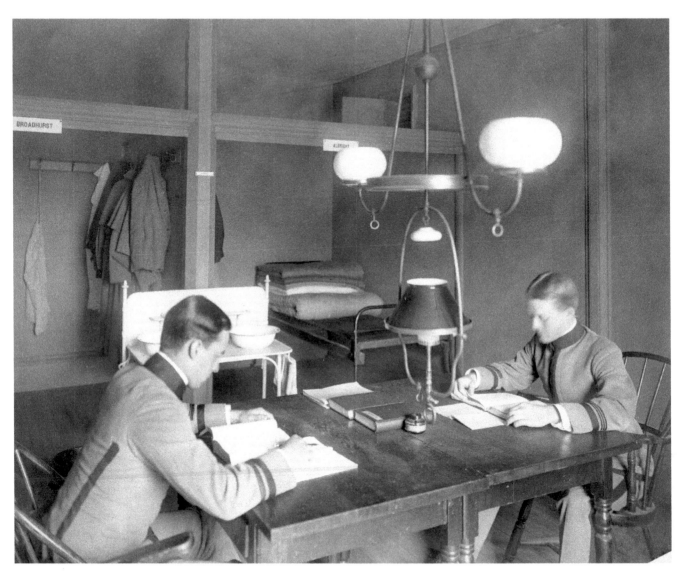

Even during the evening study period, cadets maintain high standards of personal and room appearance. Roommates learn the importance of cooperation and teamwork, and normally cultivate lifelong friendships. This photograph from around 1905 features cadets Hugh Broadhurst and Owen Albright studying in their room.

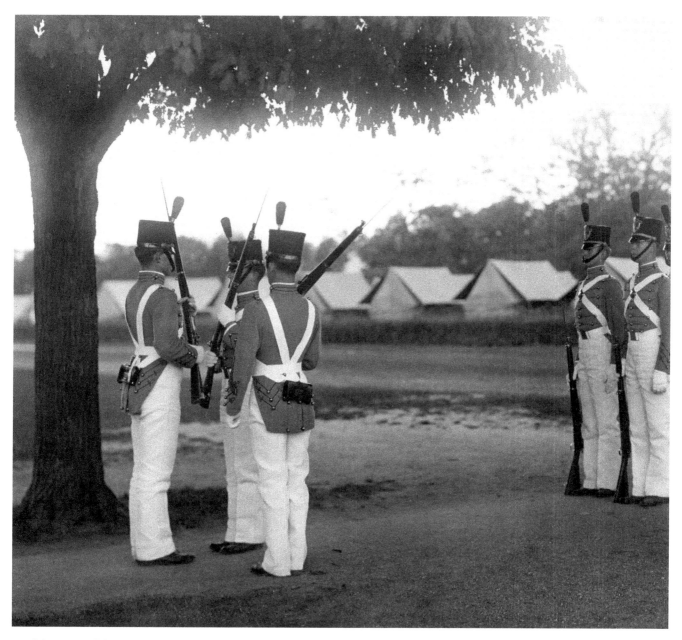

A "changing of the guard" takes place during the summer encampment. The two sentinels facing each other are changing over, as one relinquishes his post to the other, under the supervision of the sergeant of the guard (ca. 1905). Other members of the guard relief are standing by to the right.

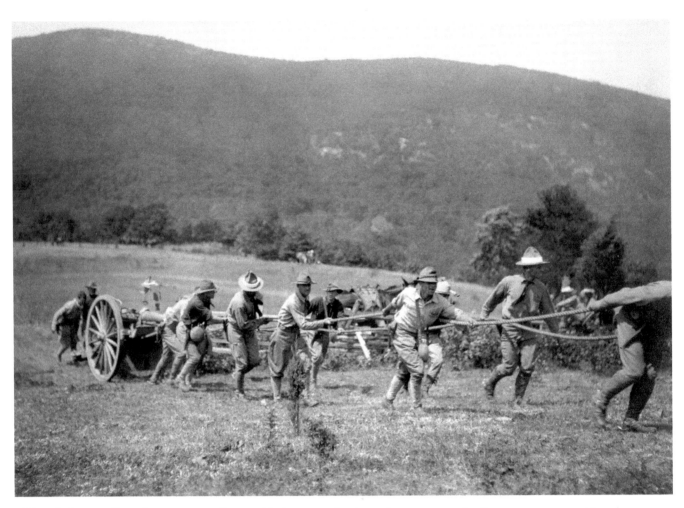

Although these artillery pieces are normally towed by horses, cadets learn that manpower is often necessary to position the guns in rough terrain. Here around 1907 cadets are pulling a howitzer into position. During the summer training periods, cadets were exposed to tactics, techniques, weapons, and equipment from multiple branches of the Army, a practice that continues today.

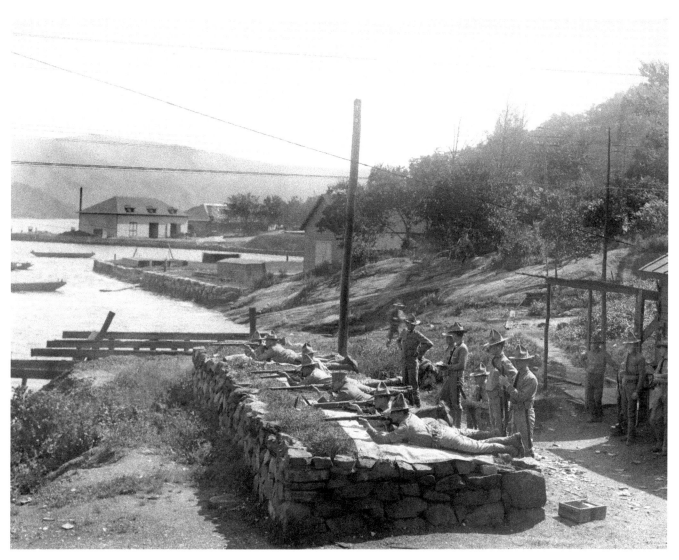

Cadets undergo marksmanship practice during the course of summer military training. Here cadets are firing from the prone position toward Target Hill field, while instructors observe. The north dock and the Hudson River are in the background.

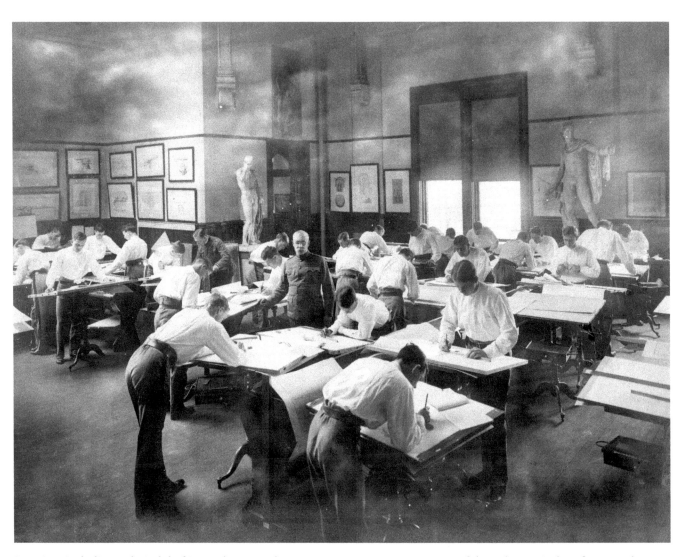

Drawing, including technical drafting and topographic mapping, was an important part of the cadet curriculum for more than 100 years. The cadets pictured here in 1907 are being taught by Colonel Charles Larned, who served on the faculty from 1874 until his death in 1911.

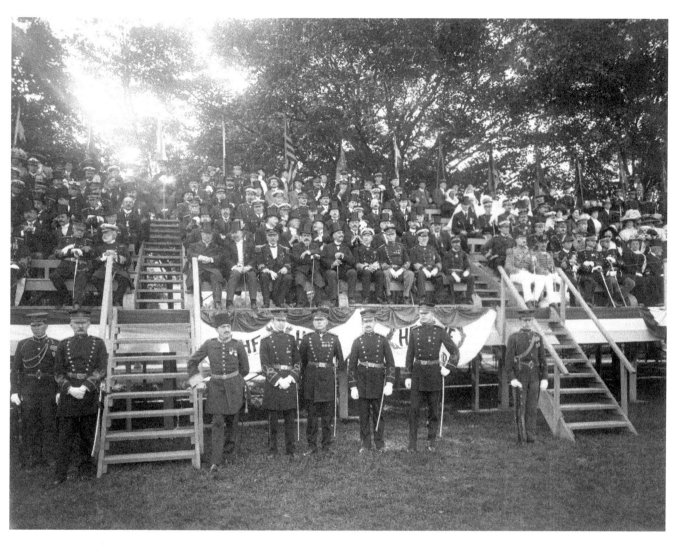

In September and October of 1909, the State of New York celebrated the 300th anniversary of Henry Hudson's trip up the Hudson and the 100th anniversary of Robert Fulton's use of steam-powered boats on the river. West Point welcomed dignitaries from several countries and gave them a full tour of the Academy. Following the tour, the guests watched a review of the Corps from the grandstands shown here.

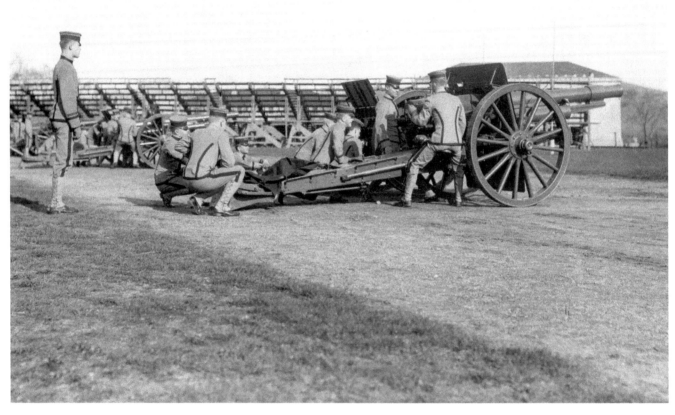

Cadets practice artillery "crew drill." This training is being conducted on the Plain, with Cullum Hall visible in the background and the Officers' Mess at far-right.

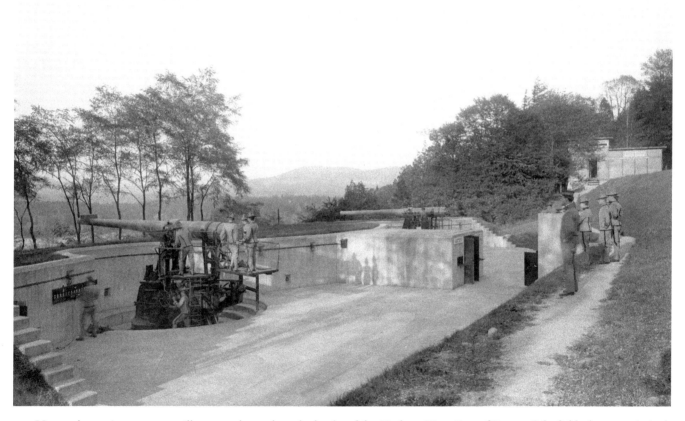

Here cadets train on coast artillery guns located on the banks of the Hudson River. Part of Battery Schofield, these are six-inch disappearing guns formerly located below Trophy Point.

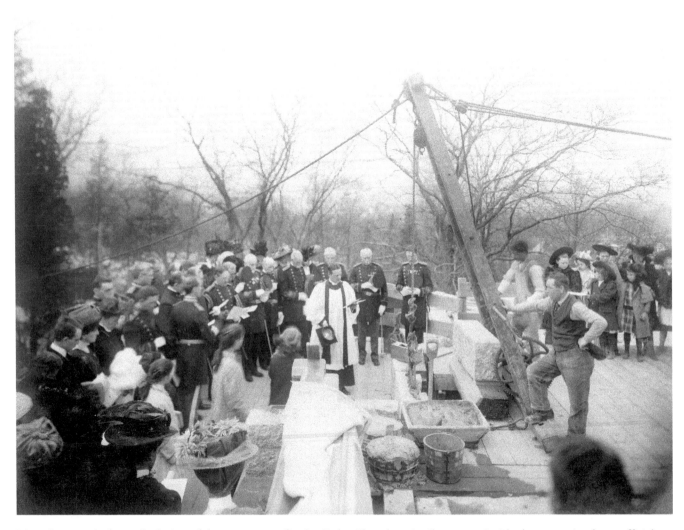

This photograph shows the laying of the cornerstone for the Cadet Chapel on April 5, 1909. Inside the stone, Academy officials placed a box containing photographs of President William Taft and former president Theodore Roosevelt.

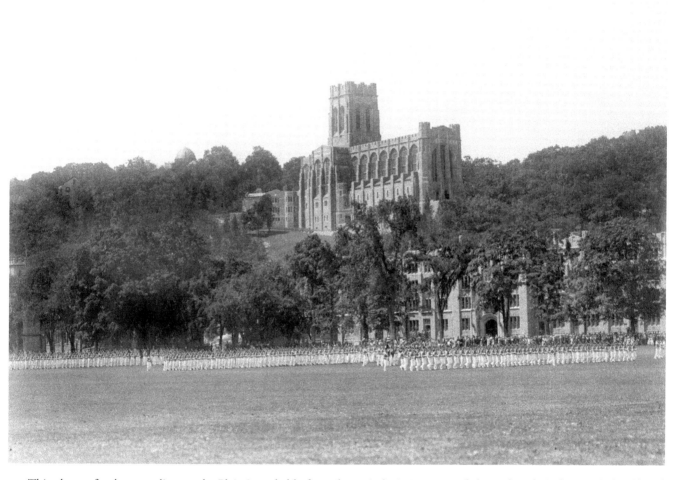

This photo of cadets parading on the Plain is probably from the period 1910–1920 and shows the relatively new Cadet Chapel rising above the Academy.

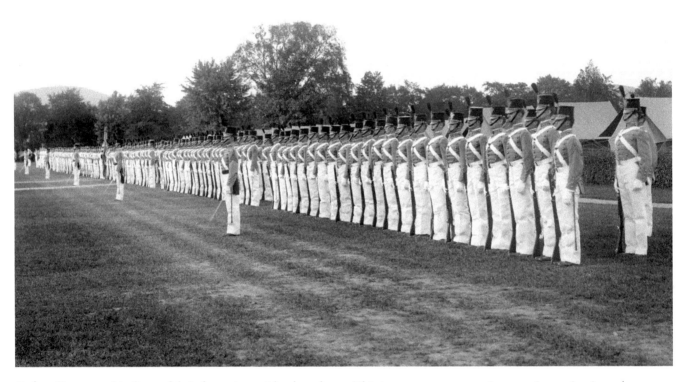

Cadet officers stand in front of their formations with sabers drawn. This is a common scene prior to an inspection in ranks or parade. This particular photograph captures a parade during summer camp.

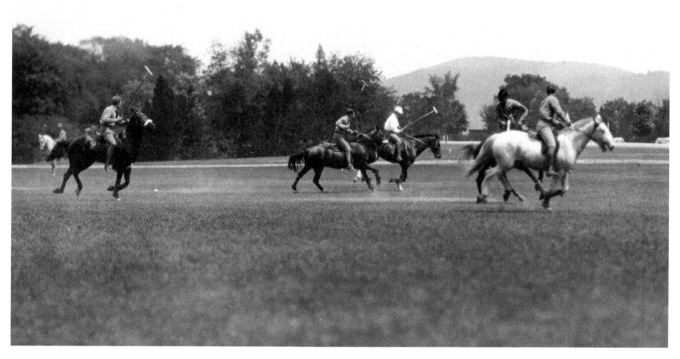

For many years, polo was a popular extracurricular activity for cadets.

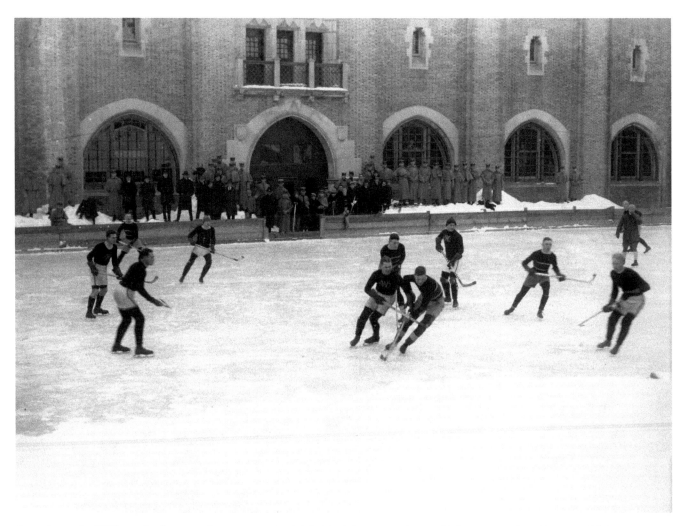

Army hosts the Williams hockey squad at an open-air rink behind the gymnasium, which was completed in 1910. This area was later destroyed as the gymnasium was expanded.

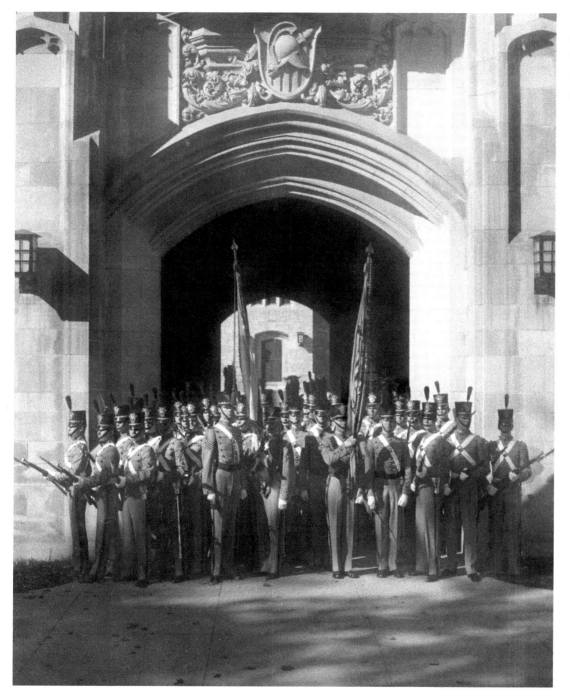

Cadets pose in front of a sally port of the North Barracks, completed in 1909 and demolished in 1963.

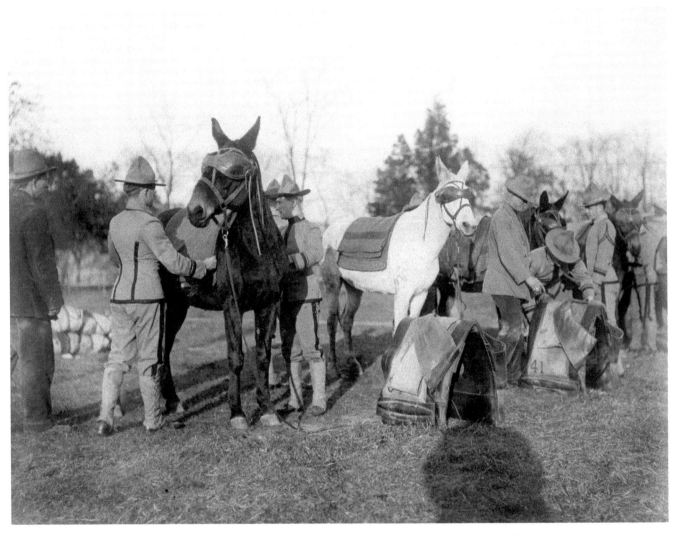

At the turn of the century mules were still essential for transporting supplies and equipment, especially over rough terrain. Here on the Plain around 1910, cadets learn how to "pack" mules with supplies and equipment prior to going to the field. These training events were known as "pack drills."

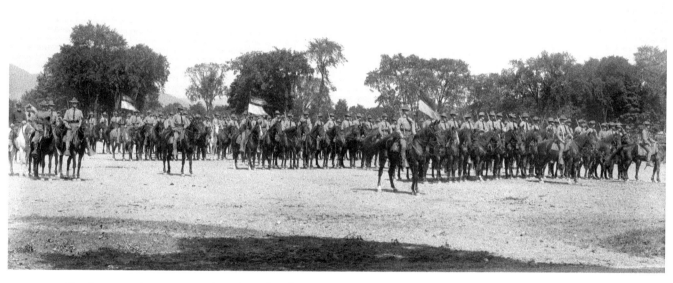

Cavalry operations were conducted on the Plain at West Point. The unit colors for three organizations are visible in this photograph. Cadets are wearing field dress uniforms with "sabers drawn."

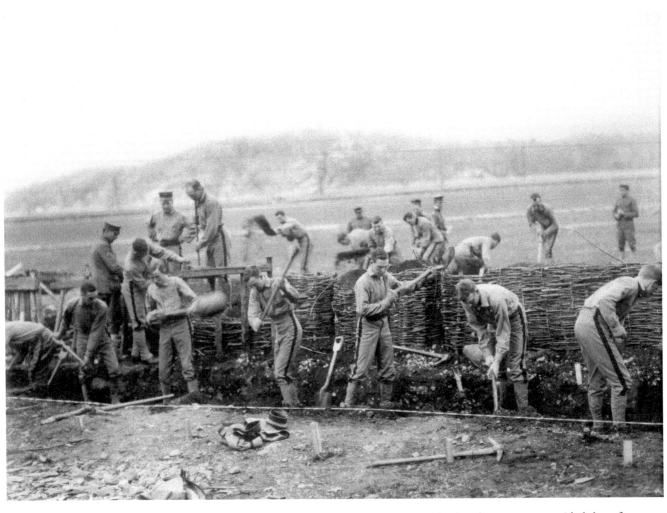

Relying on the use of picks and shovels, cadets prepare a fortified trench system. This firsthand experience provided these future officers with an appreciation of the physically demanding work often required of soldiers in the field.

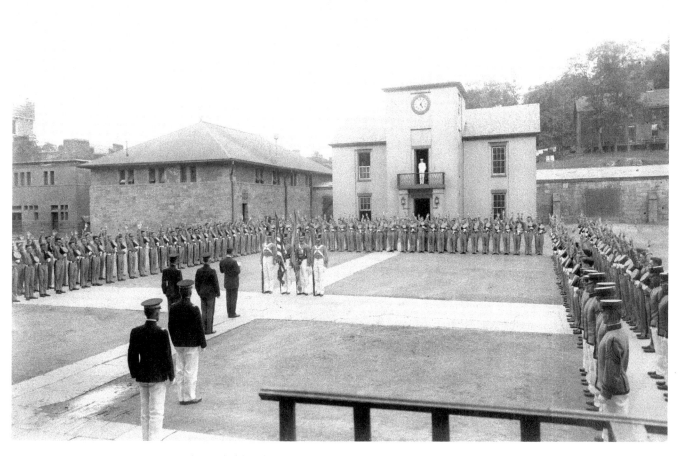

A 1913 swearing-in ceremony is being held in front of the cadet guard house, which according to many accounts also contained the Commandant's office.

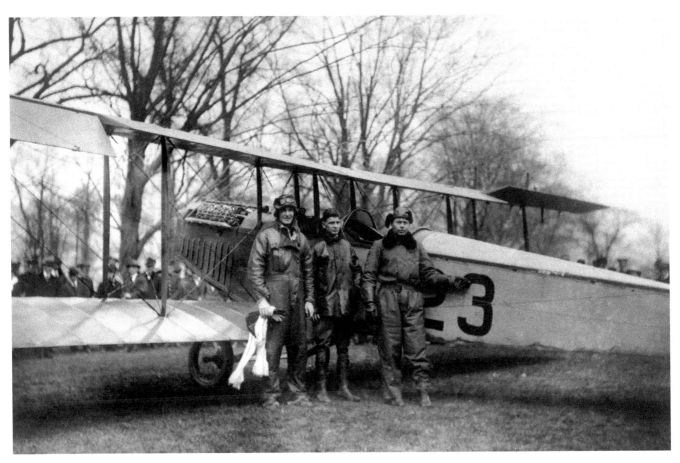

Cadets receive a demonstration of new aviation technologies.

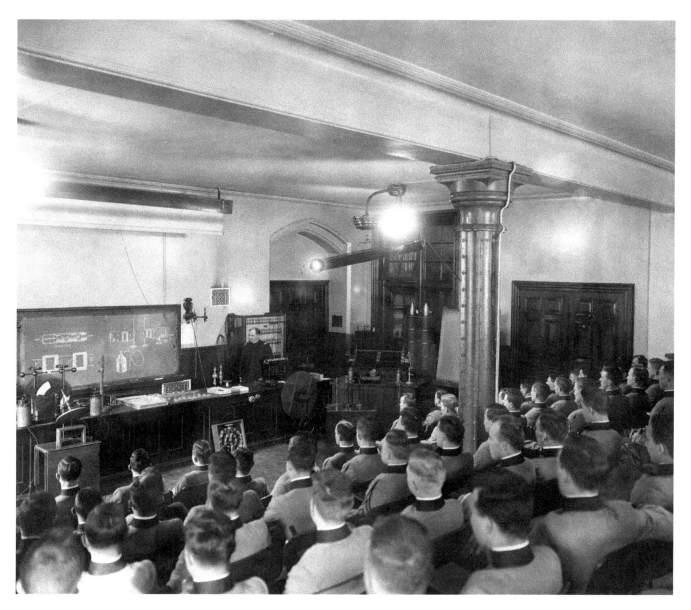

Although section sizes for normal classes are extremely small (usually less than 15 students) under the "Thayer method," cadets routinely come together in larger groups for special lectures. Here around 1912, cadets are seated in a small lecture hall to observe a chemistry experiment within the Department of Chemistry, Mineralogy, and Geology.

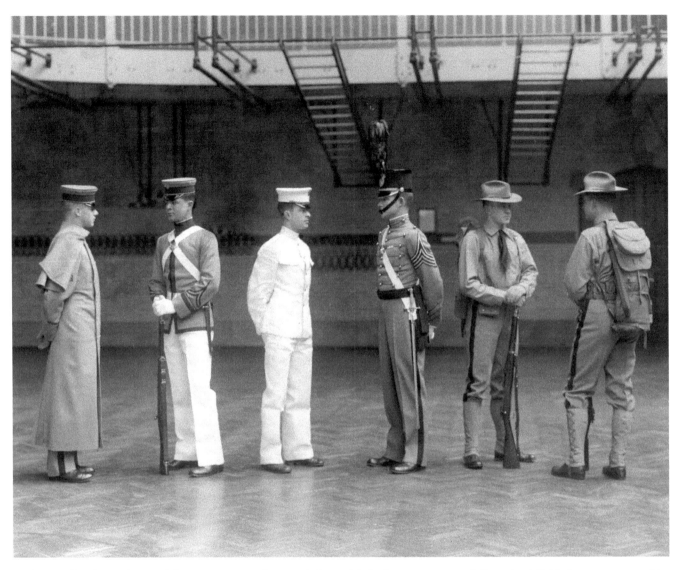

Cadets display the uniforms of the times (ca. 1914). From left are: (1) the long overcoat with "cape back;" (2) dress gray over white under arms; (3) dress whites; (4) full dress gray under arms; and (5) a front and rear view of the field uniform, including campaign hat and backpack. While under arms and in dress uniforms, underclass cadets carry rifles (second from left), whereas first-class (senior) cadets wear sabers (fourth from left). The old gymnasium served as the setting for this photograph.

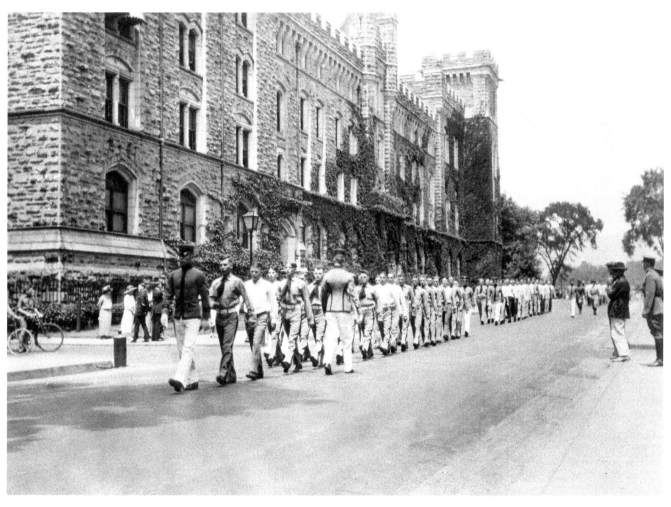

New cadets march to their first meal on Reception Day. The photograph is undated, but is probably from the 1900–1920 era.

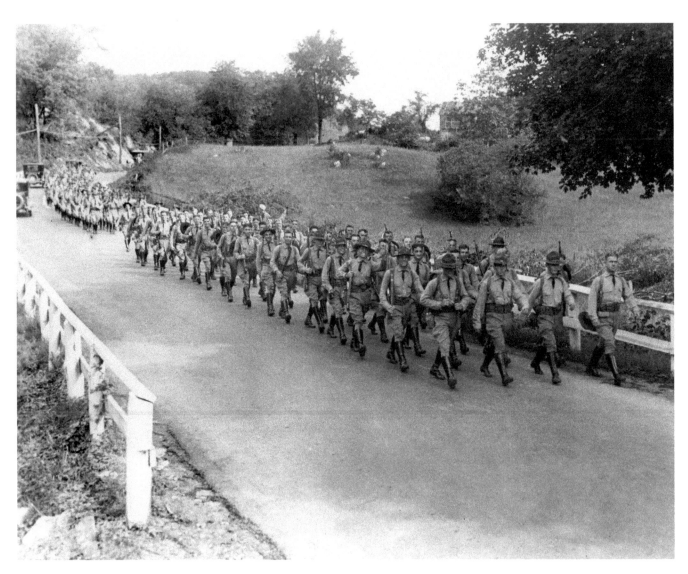

Here cadets can be seen on a road march away from the Academy in a photograph from the early twentieth century.

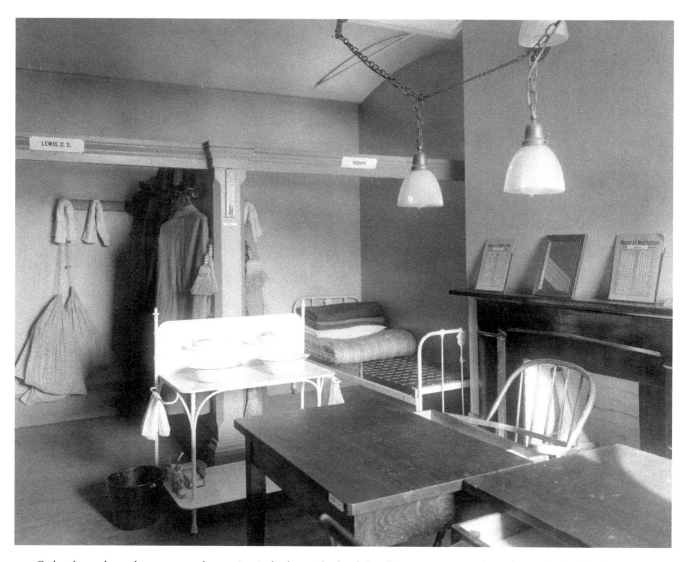

Cadets have always been expected to maintain high standards of cleanliness, neatness, and good organization in their rooms, as evidenced by this 1917 photograph. The barracks rooms are inspected on a daily basis. Name tags are posted above the bunks and on the desk. Traditionally, cadets have been housed in two-person rooms, and although the furnishings have changed through the ages, the room standards have remained relatively constant.

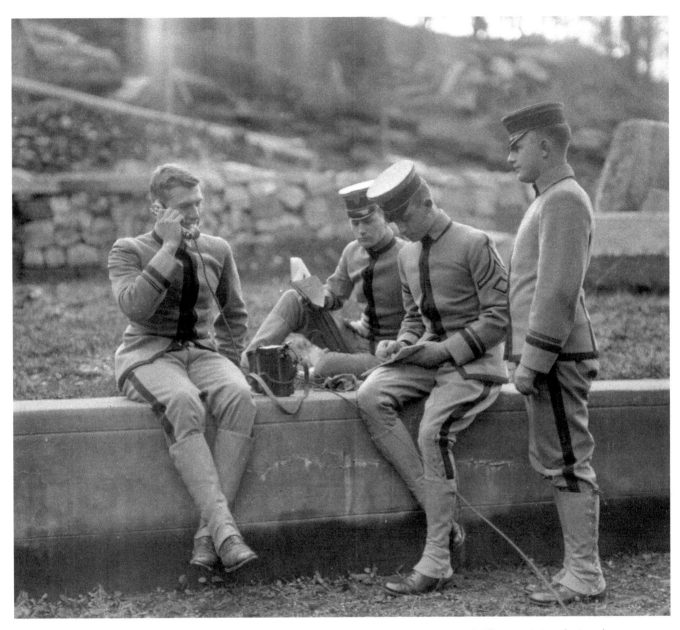

Cadets learn to operate a field telephone during the course of this summer training session. Military training during the summer months has always been designed to develop leadership, while exposing cadets to tactics, techniques, and a wide range of equipment and weapons systems.

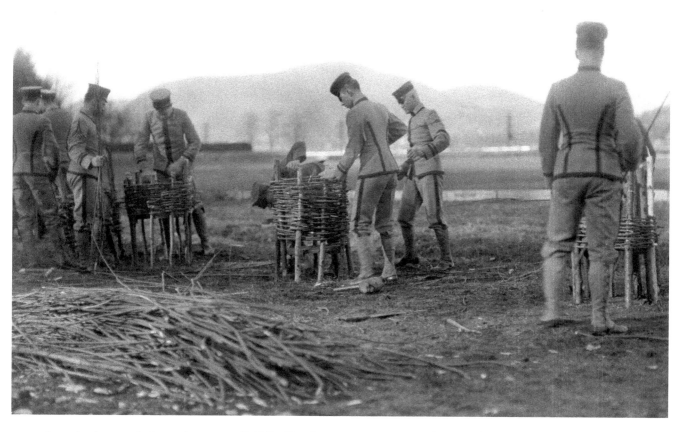

Learning how to design and construct field fortifications was once an integral part of the engineering curriculum during the academic year, and summer training afforded opportunities for practical application. Here cadets learn how to construct "gabions" (baskets made of saplings and filled with stones and dirt), used in building field fortifications.

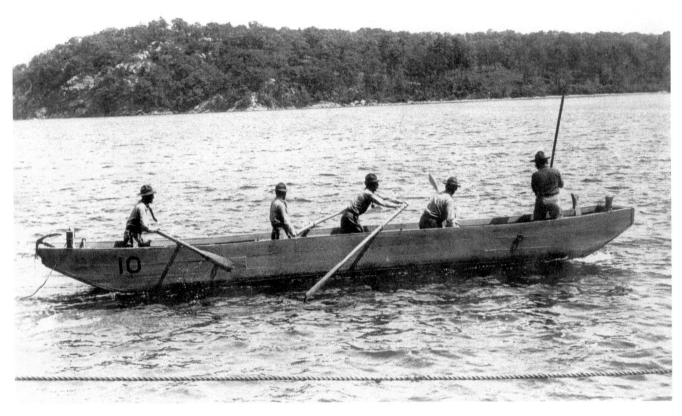

During their summer training around 1918, cadets maneuver a pontoon into position as part of a bridge construction exercise across the Hudson River, staged off the North Dock, with Constitution Island in the background. Engineering training, to include the construction of pontoon bridges, continues to be a part of cadet field training each summer, although the training is now conducted at Lake Stillwell rather than on the Hudson River.

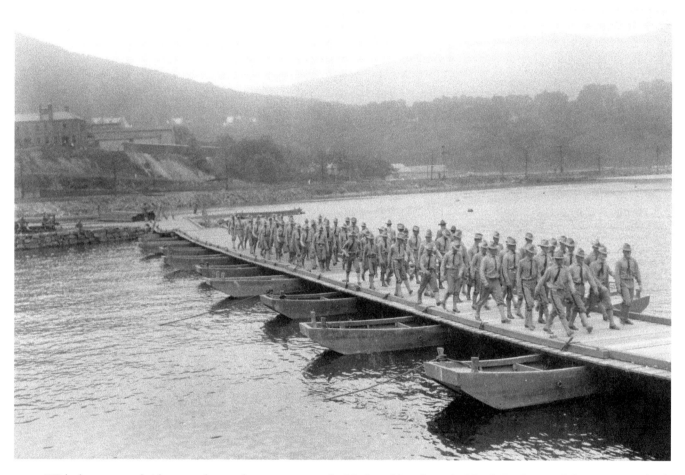

With the pontoon bridge complete, cadets move across the Hudson River from the North Dock toward Constitution Island.

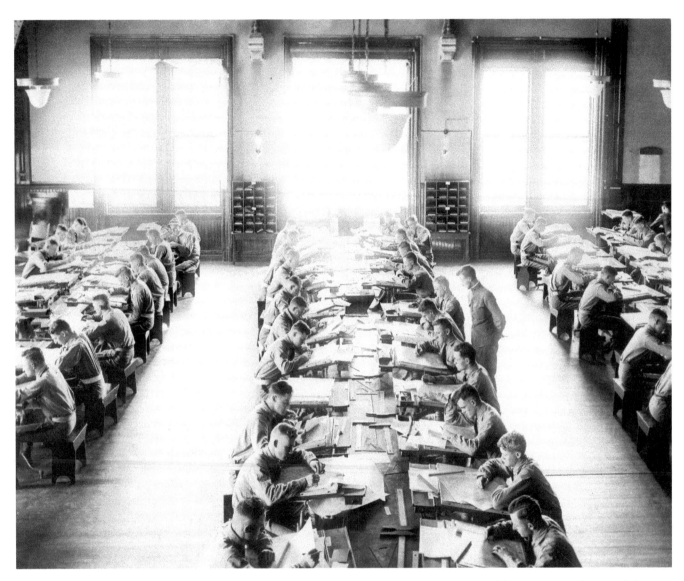

Cadets participate in a drawing class around 1918. Military and mechanical drawing was part of the core curriculum until the 1980s. Visible on the drafting tables are T-squares, triangles, scales, compasses, and lettering sets, all essential items for this particular class.

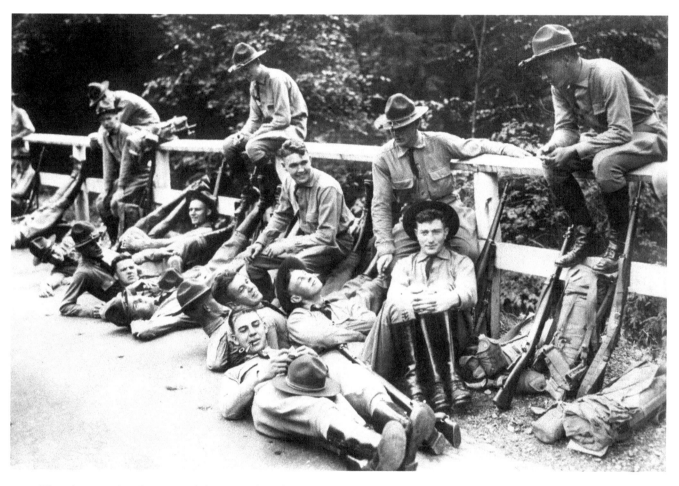

This photograph, taken around the time of World War I, shows cadets resting during a march to Camp Smith near Peekskill, New York.

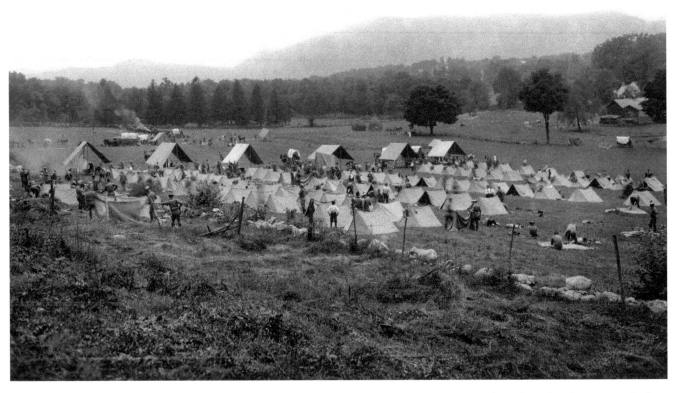

This tent city was part of a bivouac site and a base from which additional field training was conducted. Each cadet was required to carry a "shelter half" in his field pack. When paired with a partner, the two cadets could assemble a "pup tent" designed for both individuals. The larger tents were used to house field kitchens.

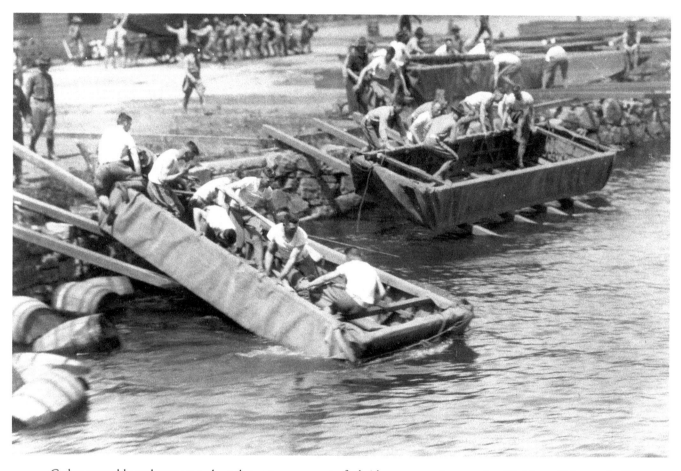

Cadets assemble and prepare to launch pontoons as part of a bridge construction exercise. Division of labor and reliance on cooperation and teamwork were essential. Here the work progresses from the shore to the water's edge and eventually out onto the river. In the foreground two pontoons are being launched into the Hudson River (ca. 1918).

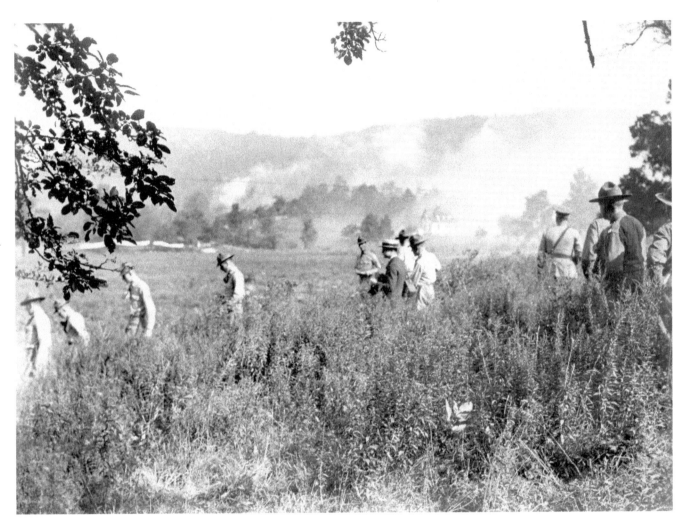

This scene depicts a live-fire training exercise conducted during the summer. Cadets learn to maneuver under rifle, machine-gun, and artillery fire. Such exercises were intended to instill confidence and create realistic battlefield conditions, while training cadets on movement techniques and demonstrating the effects of combined arms. Artillery rounds can be seen bursting on the hills in the background.

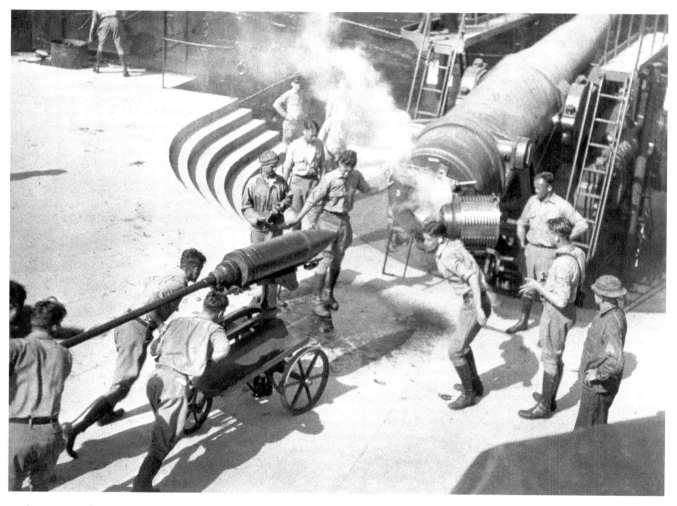

A large crew of cadets is required to fire this coast artillery gun. The quartet to the left front is preparing to load a new round into the breech.

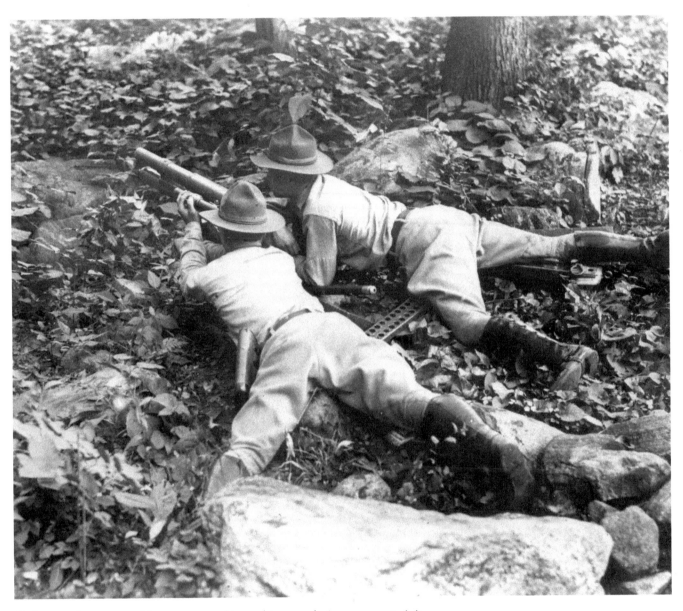

Cadets use the prone position to operate this machine gun during summer training.

BETWEEN TWO WARS

(1919–1939)

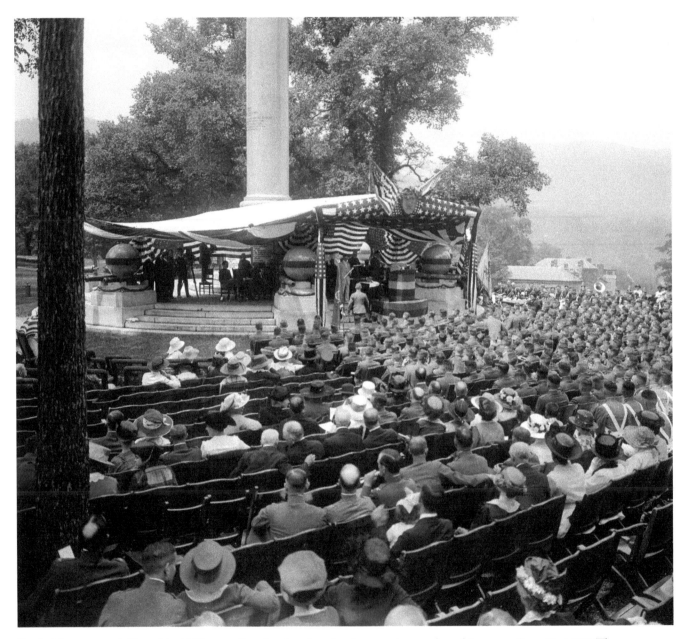

Battle Monument, dedicated in 1897, was often the site of graduation exercises, such as this one on June 11, 1919. The Monument was designed by famed architect Stamford White, who designed the Washington Square Arch and second Madison Square Garden in New York City. White was infamously shot in 1906 by the husband of one of his mistresses.

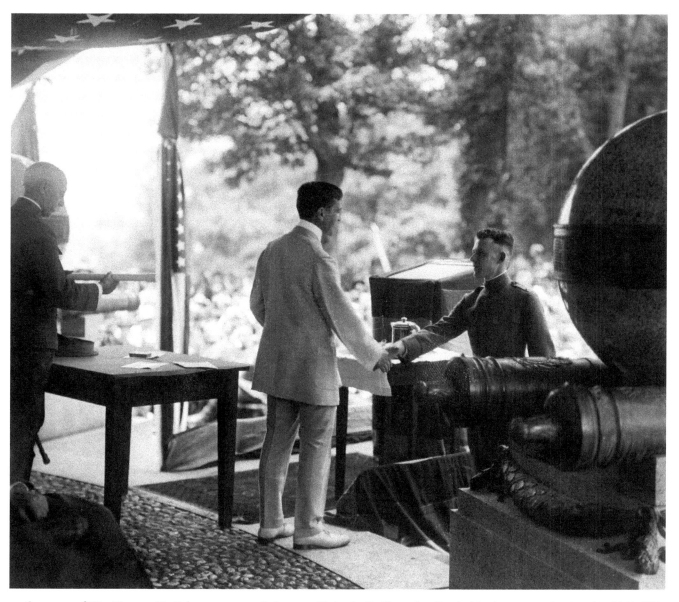

Secretary of War Newton D. Baker presents a diploma to Cadet L. G. Horowitz, first in his class, on graduation day 1919. This was also the day that Douglas MacArthur became Superintendent of the Academy.

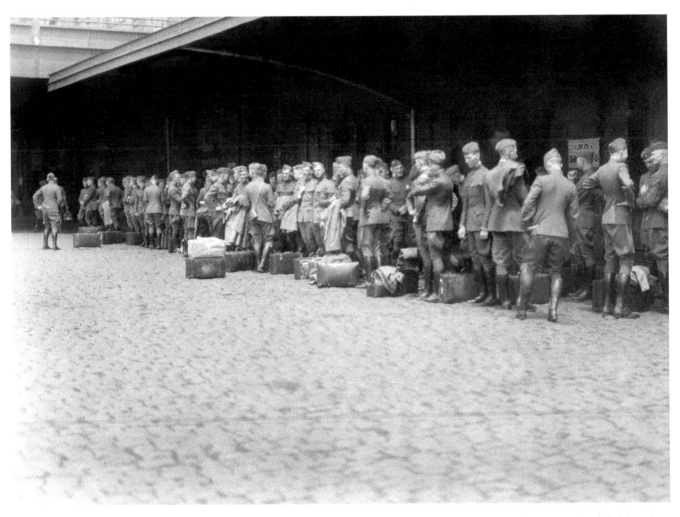

In the summer of 1919, the entire graduating class of cadets was taken to Europe for nearly two months to view battlefields and the effects of war firsthand. Here they prepare to leave.

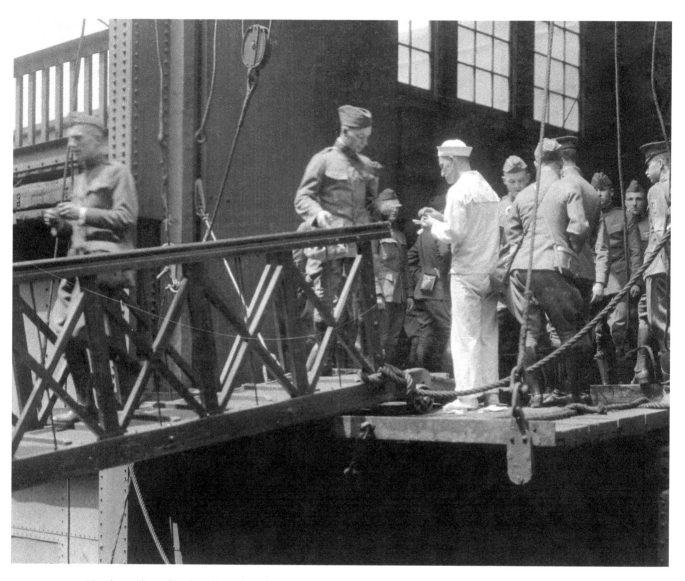

Newly graduated cadets from the Class of 1919 board the Army transport *Leviathan* en route to France for a tour of the battlefields.

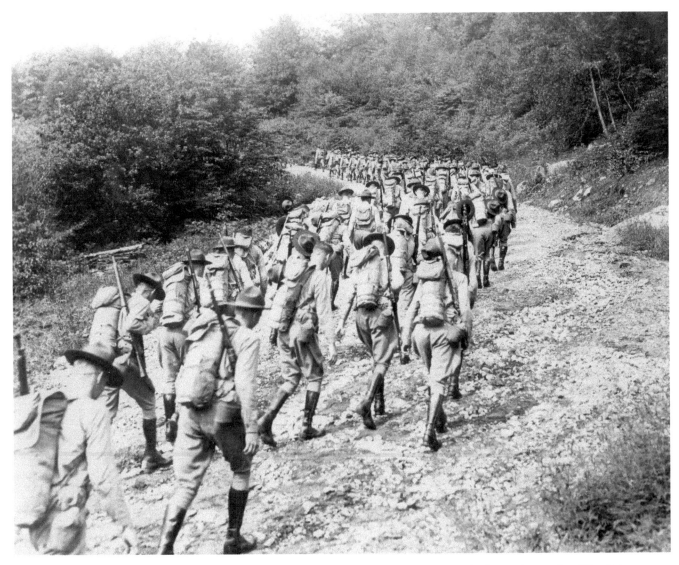

New cadets from the Class of 1930 get their first taste of an Army foot march. This particular hike originated at West Point and proceeded to Camp Smith on the east side of the Hudson River, where the cadets encamped and conducted additional field training.

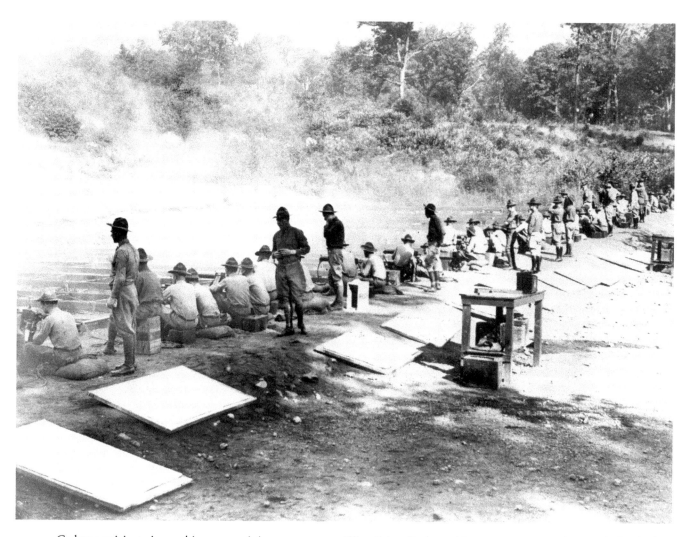

Cadets participate in machine-gun training on a range at West Point. Each machine-gun crew comprises two individuals: a gunner, who engages the targets, and an assistant gunner, who feeds the belt of ammunition into the gun and helps to change the barrel if it overheats. Officers and senior cadets observe the firing and coach and evaluate the gunners on the firing line.

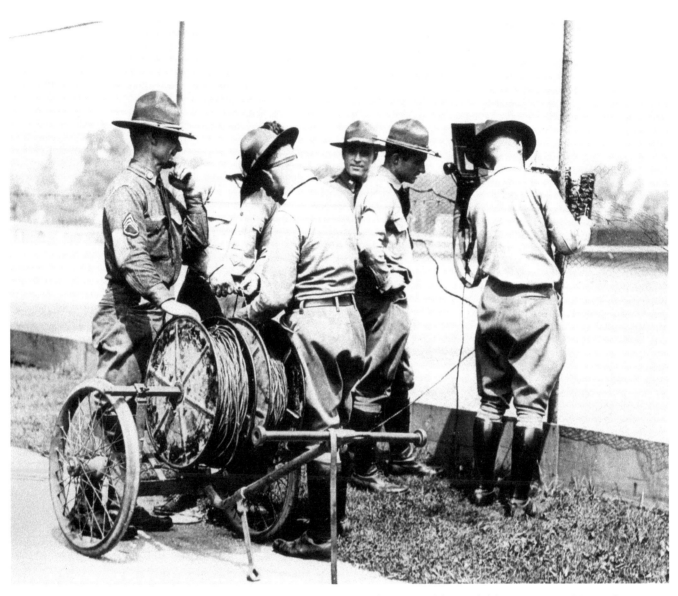

During the summer training periods cadets are exposed to as many branches as possible in a field environment. Here cadets learn to install and operate a field telephone. The individual at far-left is a staff sergeant, as indicated by the rank on his upper-right sleeve.

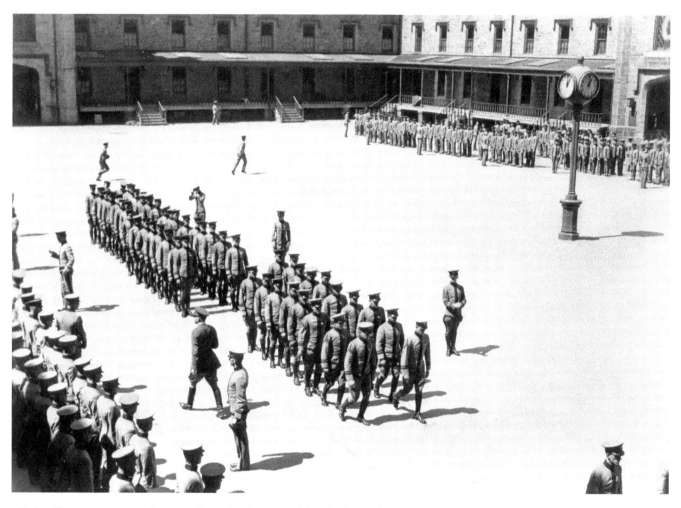

Cadets form up to go to afternoon classes in the 1920s. The clock is striking 1:00 (1300 hours). The buildings visible are barracks that no longer exist.

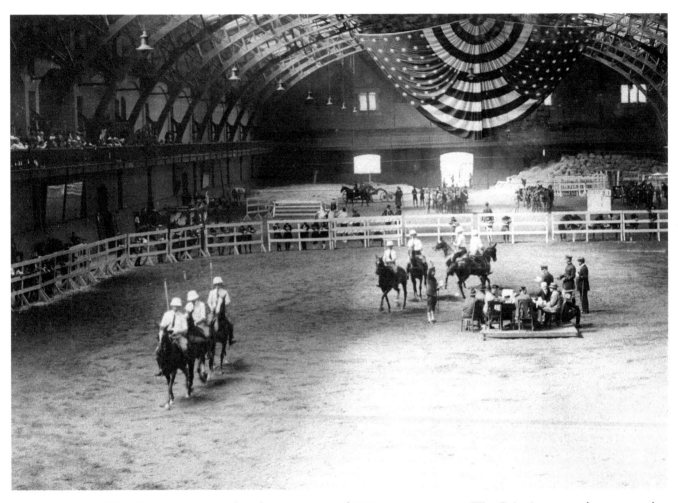

Horse shows and riding demonstrations, such as this one in June of 1922, were common at West Point in an era when every cadet was expected to know how to ride.

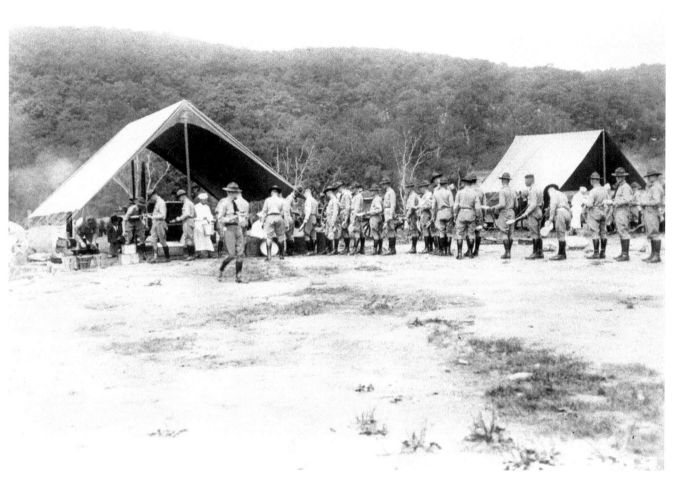

New cadets from the Class of 1930 proceed through the mess tent at Camp Smith, located across the river from West Point. Two separate field kitchens are in operation and the cooks are wearing their "whites."

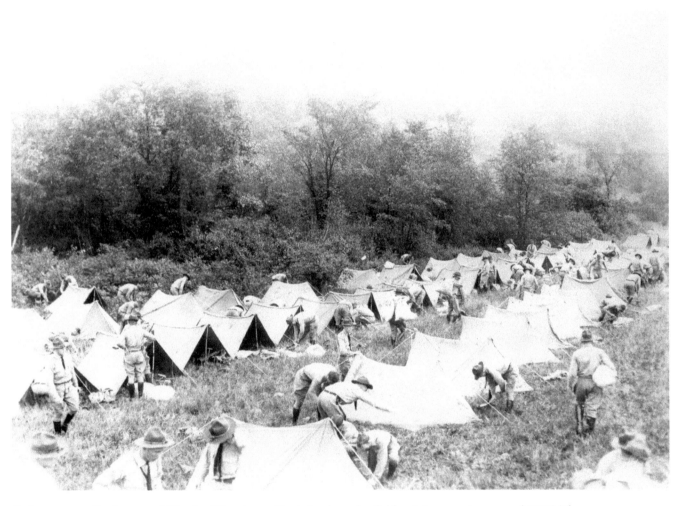

Cadets encamp for the annual "Battle of Popolopen Creek," a three-day field training exercise, around 1926. The two upper classes erected pup tents and established a bivouac site at the mouth of Popolopen Creek, approximately 12 miles south of West Point. This was the site of the twin forts of the Popolopen (forts Montgomery and Clinton), where an important Revolutionary War battle took place.

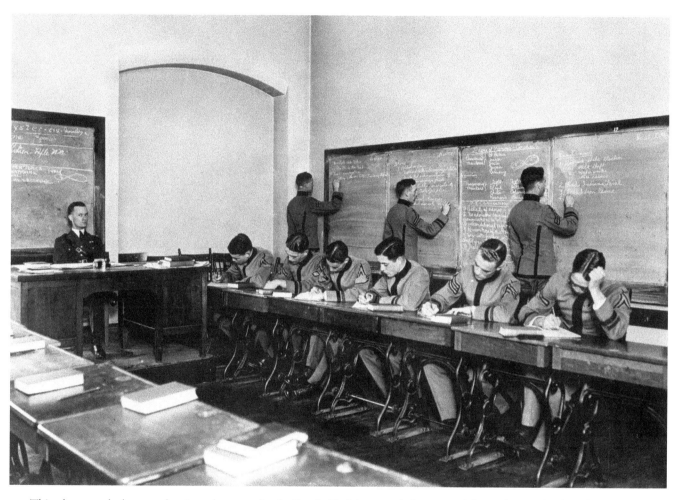

This photograph shows cadets in a classroom in the first half of the twentieth century. The tradition of "taking boards," that is, going to a blackboard to write answers, dates to the nineteenth century.

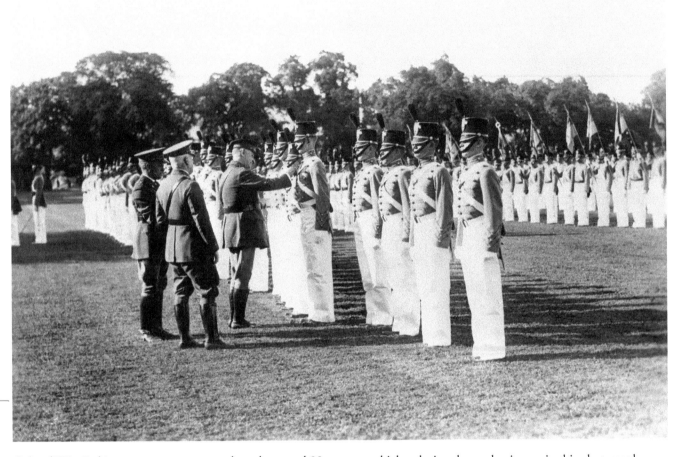

Colonel Wirt Robinson presents stars to cadets who scored 92 percent or higher during the academic year in this photograph presumably from the 1920s. Robinson taught chemistry at the Academy for more than 20 years.

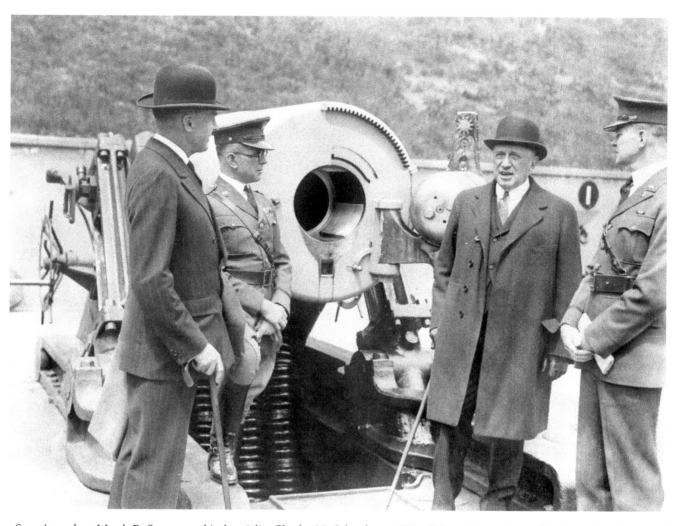

Superintendent Merch B. Stewart and industrialist Charles M. Schwab tour West Point with members of the American Society of Mechanical Engineers. Schwab reportedly once said to a group of cadets, "I have a speech here I planned to deliver but I guess I'll let you read it in the morning newspapers."

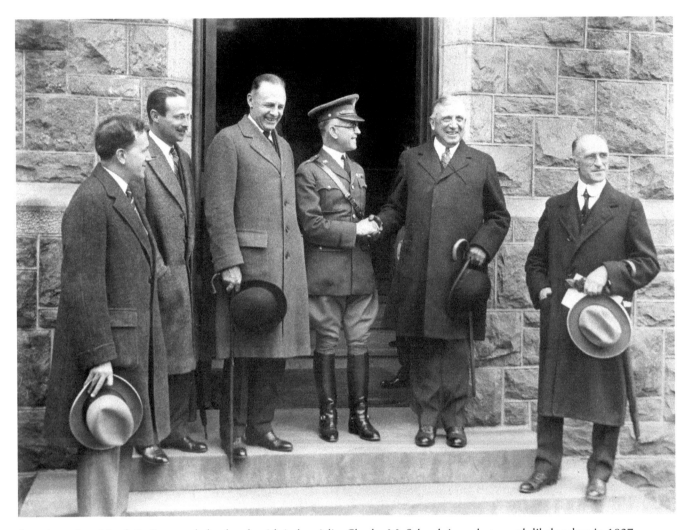

Superintendent Merch B. Stewart shakes hands with industrialist Charles M. Schwab in a photograph likely taken in 1927. Schwab, once called a "master hustler" by Thomas Edison, made his fortune in the steel industry but spent lavishly. Within years of this image, Schwab would lose his entire fortune in the stock market crash of 1929, spending the last decade of his life mired in debt and living in a small apartment.

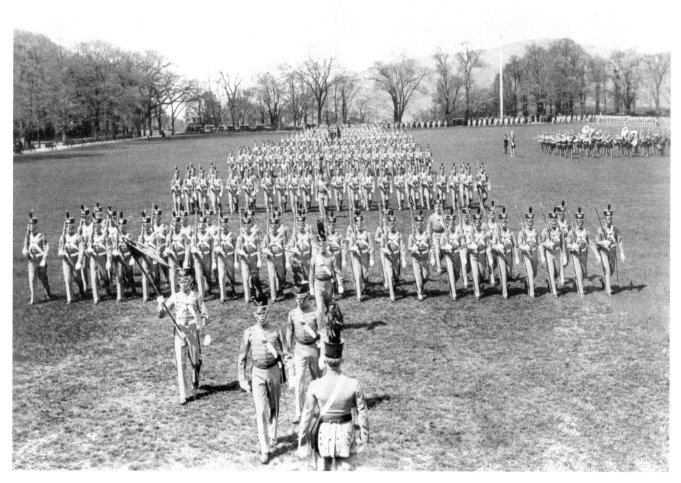

The Corps of Cadets on parade.

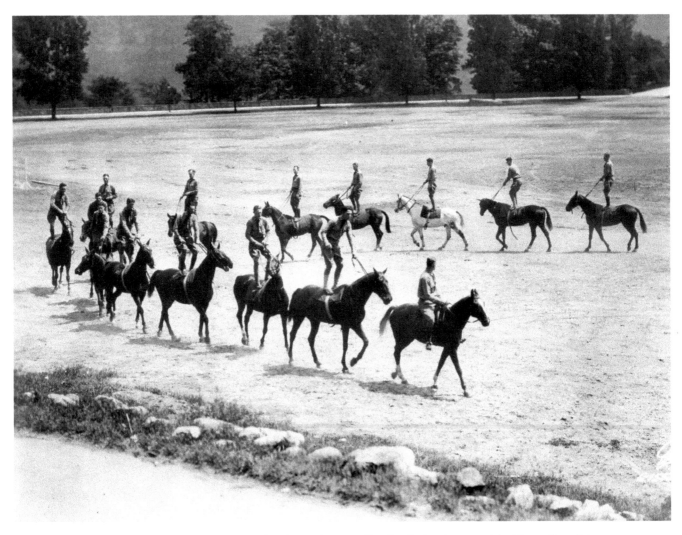

Horseback riding is a skill that few cadets have today, but in the past all cadets had to learn to ride. Here a few of them demonstrate circus riding on the Plain.

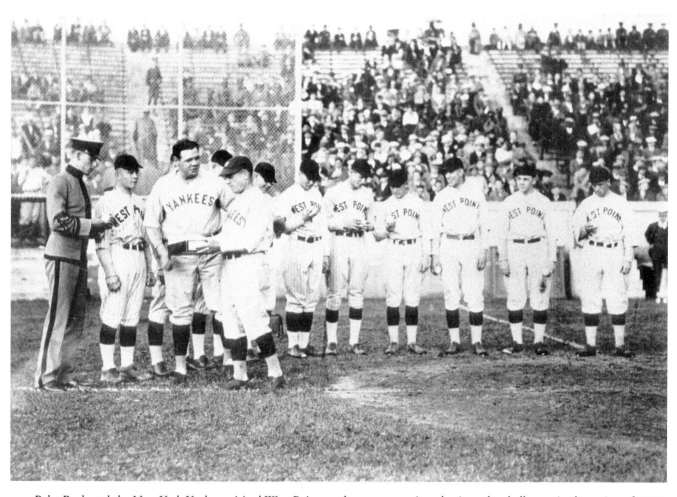

Babe Ruth and the New York Yankees visited West Point to play a game against the Army baseball team in the spring of 1927. With a good crowd on hand at Doubleday Field, the Babe handed out autographed baseballs to each member of the Army team before the start of the game.

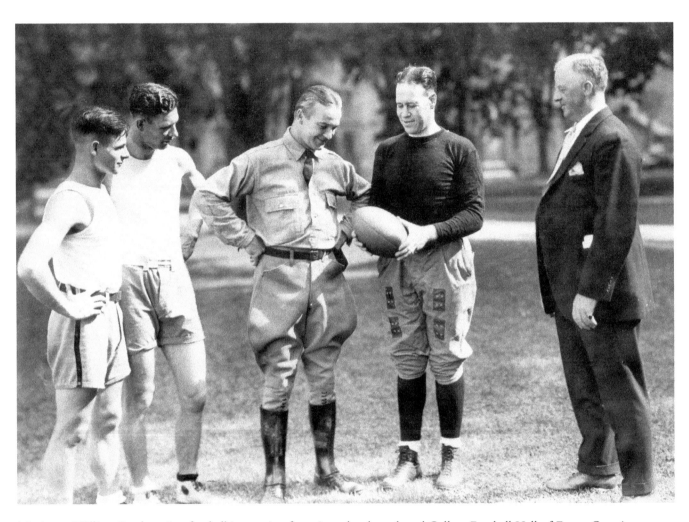

Movie star William Boyd receives football instruction from Army head coach and College Football Hall-of-Famer Captain Lawrence "Biff" Jones during the 1927 filming of the DeMille Pictures Corporation's *Dress Parade*. The Army team was 9-1 in 1927. In time, Jones would also coach at Louisiana State University, Oklahoma, and Nebraska.

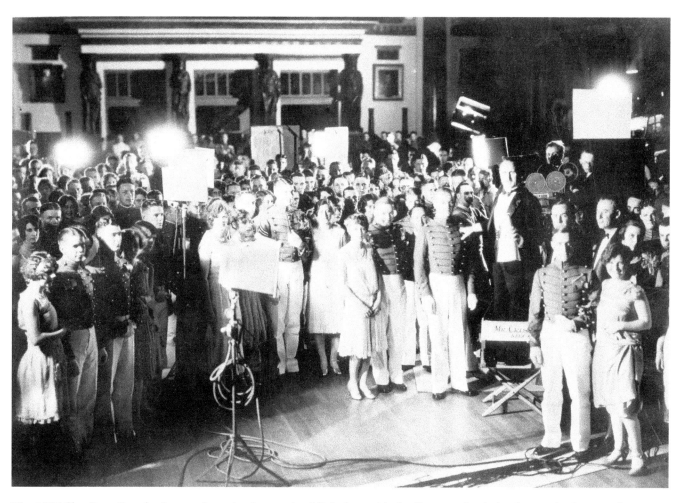

The 1927 film *Dress Parade*, about a champion boxer who falls in love with the Commandant's daughter and subsequently wins an appointment to the Academy, included many scenes filmed on location at West Point. Here cameras roll on the weekly Saturday night "hop." The film starred a young William Boyd, best known for his long stint as Hopalong Cassidy.

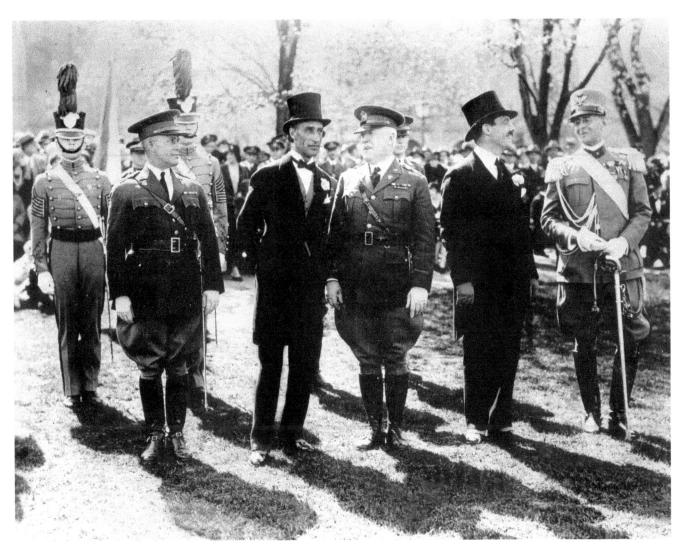

Prince Ludovico Spada Potenziani, the fascist governor (mayor) of Rome, tours West Point in 1928.

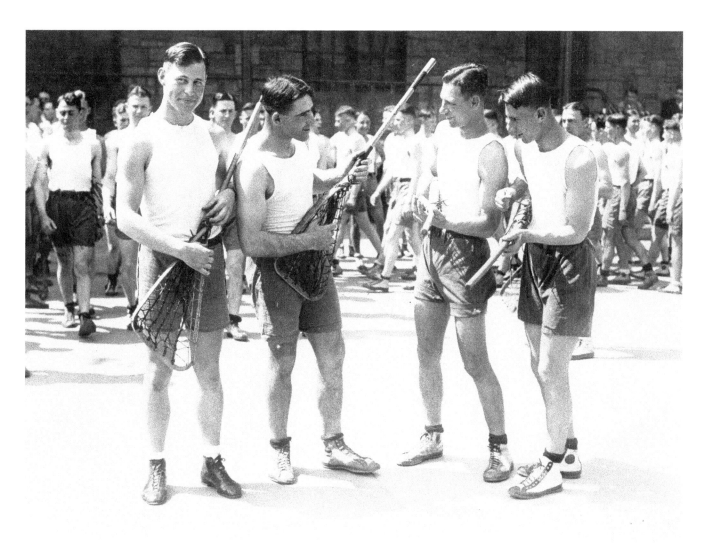

Members of the cadet lacrosse squad ham it up.

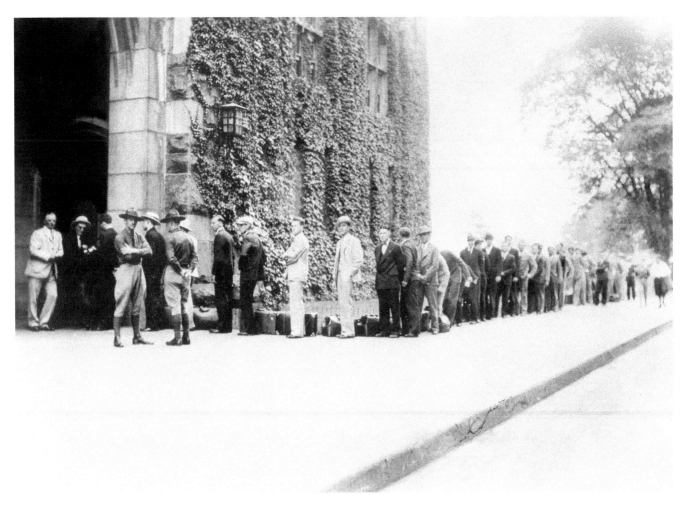

A dapper-looking group of young men arrive for Reception Day. The new cadets are queuing up in front of the Administration Building, now known as Taylor Hall. The building is no longer covered with ivy.

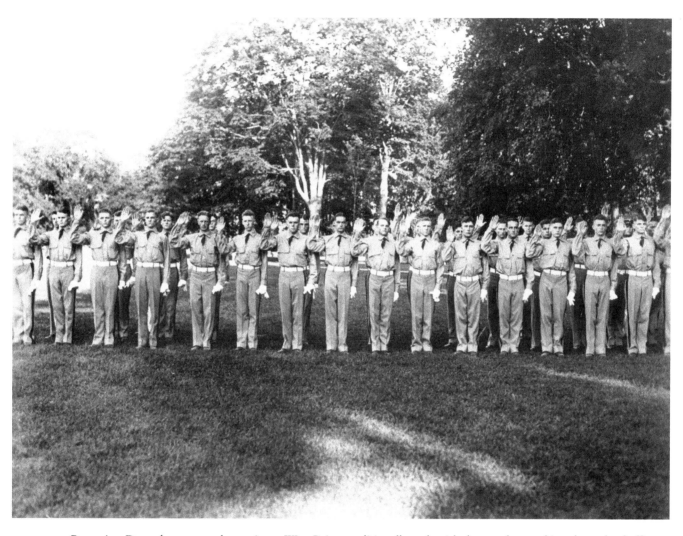

Reception Day, when new cadets arrive at West Point, traditionally ends with the neophytes taking the oath of office to acknowledge their new status as members of the Army.

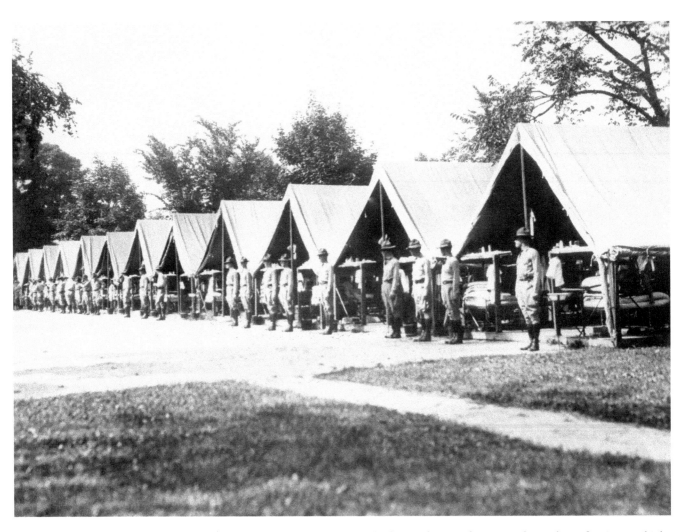

Cadets line up for inspection during summer camp. The platform tents had enough space for cots and even basic furniture, which was often carried by cadets from their barracks to the camp location on the northeast corner of the Plain.

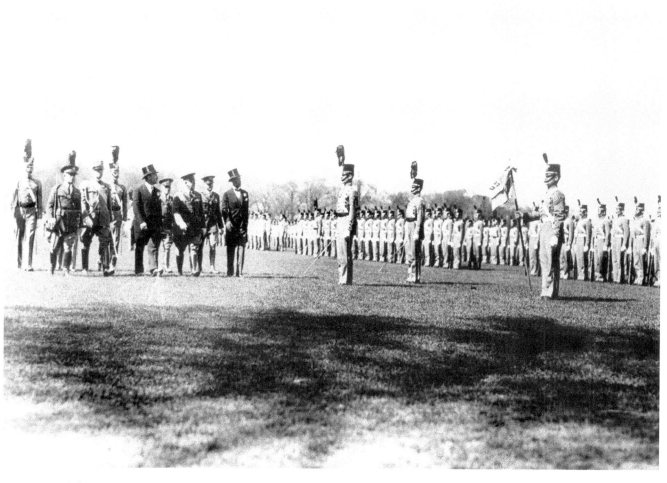

The Fascist governor (mayor) of Rome, Prince Ludovico Spada Potenziani, reviews the Corps of Cadets in May 1928.

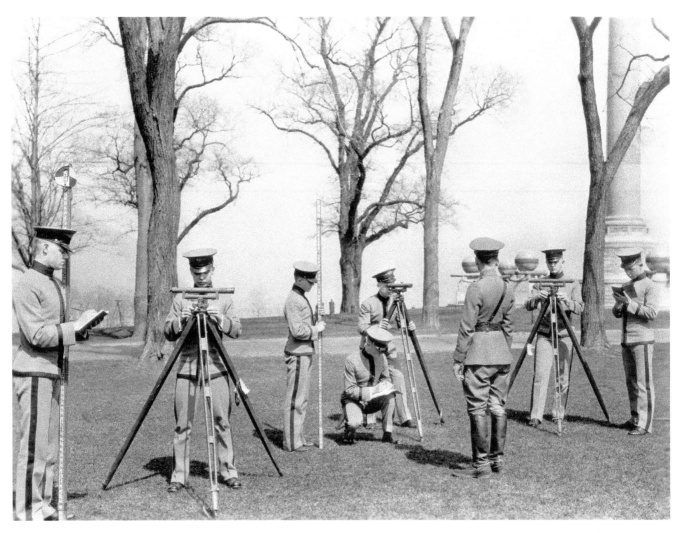

Cadets receive instruction on the use of survey equipment on the Plain. Battle Monument is in the right background. The instructor (with back toward the photographer) is wearing the officer duty uniform of the day, while cadets are in dress gray (1930s).

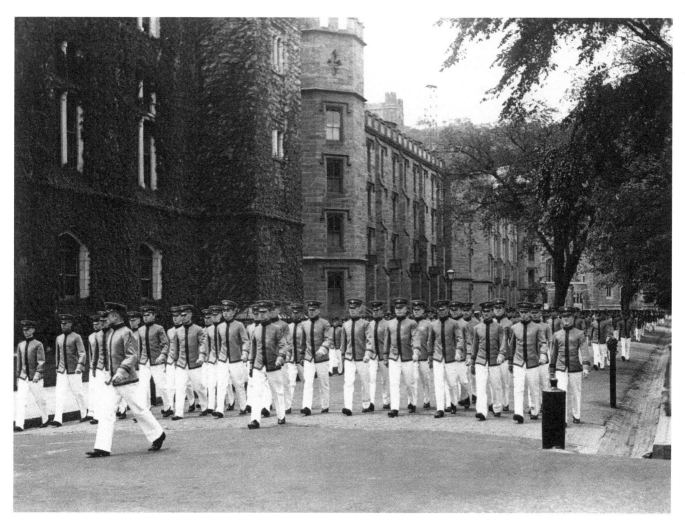

Cadets march past the old barracks and the ivy-covered West Academic Building (now Pershing Hall).

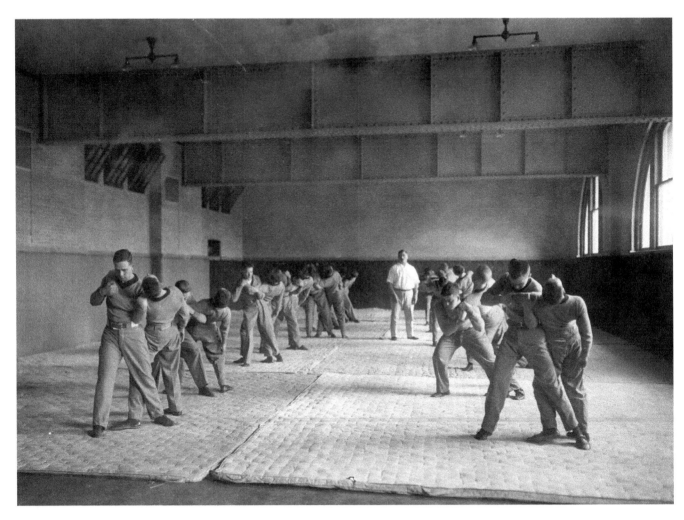

Wrestling was a part of the physical development curriculum and a required course for all male cadets through the late 1990s. In this wrestling class, cadets practice various "take-down" moves, while the instructor (middle of photo) observes (ca. 1933).

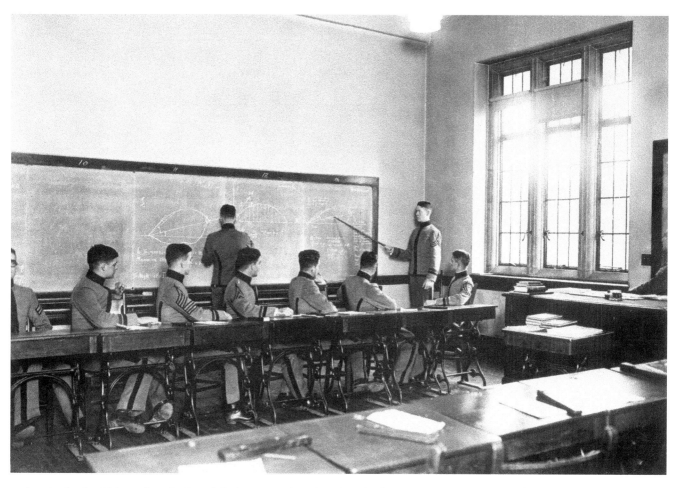

A cadet "recites" his work at the board during an engineering class. Daily recitations were an integral part of the Thayer method. Classmates pay close attention and await constructive criticism from the instructor, seated at far-right.

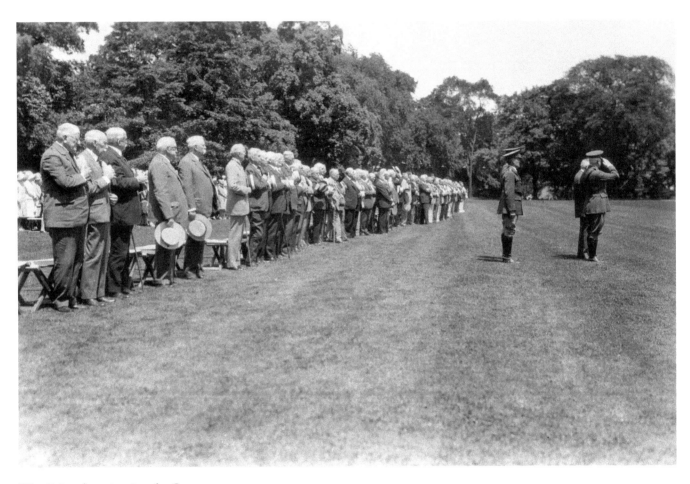

West Point alumni review the Corps.

THE LONG GRAY LINE IN WAR AND PEACE

(1940–1952)

The Corps of Cadets passes in review during a parade on the Plain in 1944. The color guard is featured in this particular picture. The upperclass cadet officers have tall, feathered plumes on their "tarbuckets," while underclassmen have a black, wool pompom.

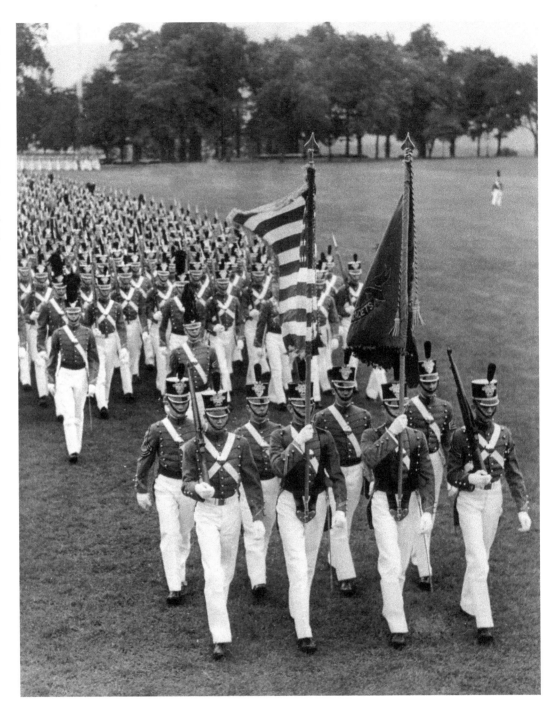

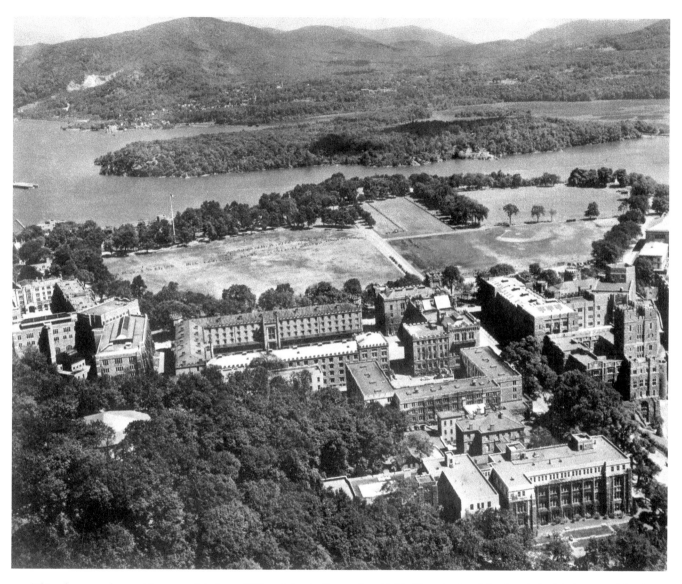

This photograph provides an aerial view of West Point in September 1944. Constitution Island and the Hudson Highlands are visible in the distance.

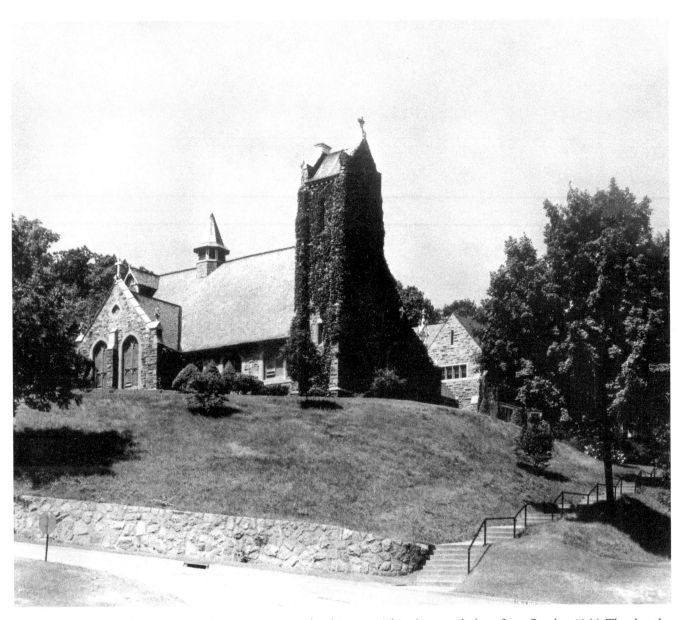

West Point's Catholic chapel, Most Holy Trinity, was completed in 1900. This photograph dates from October 1944. The chapel no longer has ivy on the tower.

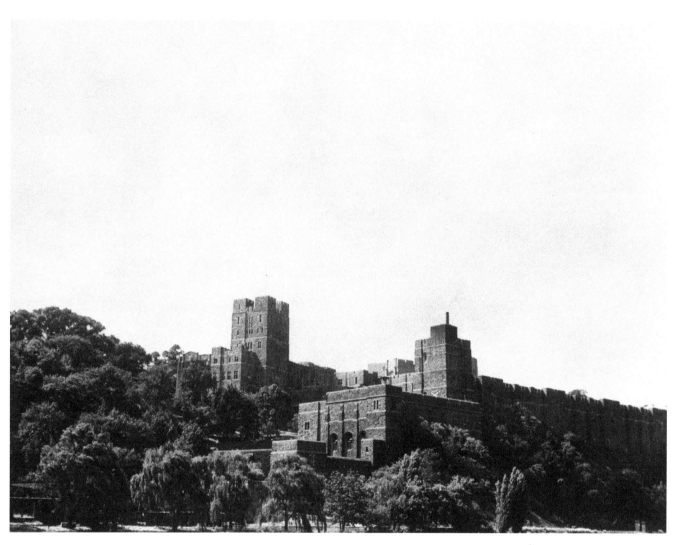

This October 1944 photograph of West Point from the Hudson River shows Taylor Hall on the left and Thayer Hall on the right.

Completed in 1910 by the architectural firm of Cram, Goodhue, and Ferguson, Taylor Hall, shown here in 1944, is an impressive example of Collegiate Gothic architecture.

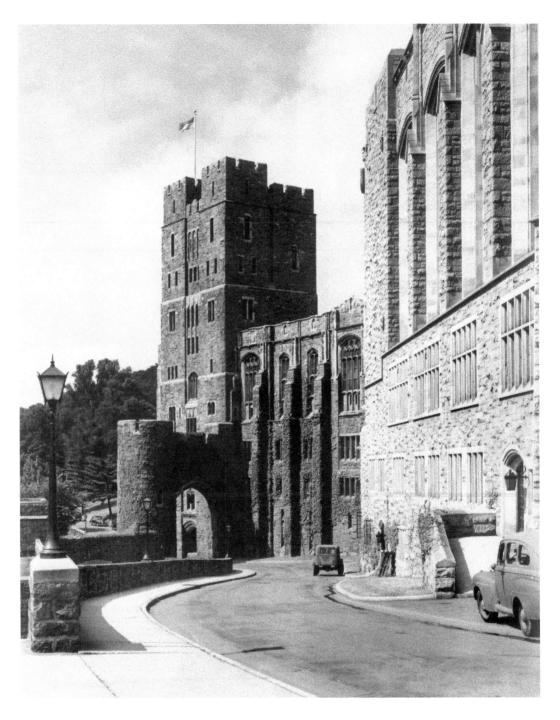

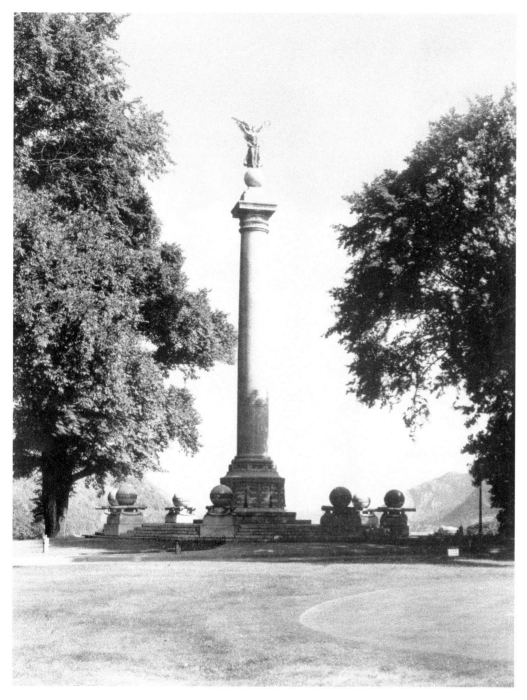

The Battle Monument, shown here in 1944, was completed in 1896 and dedicated in 1897 to remember 2,230 officers and soldiers of the regular army who perished in the Civil War. Its greatest feature is a 46-foot-tall column of pink marble from Milford, Massachusetts. The column had to be brought up from the Hudson on temporary railroad tracks. A statue of Fame graces the top.

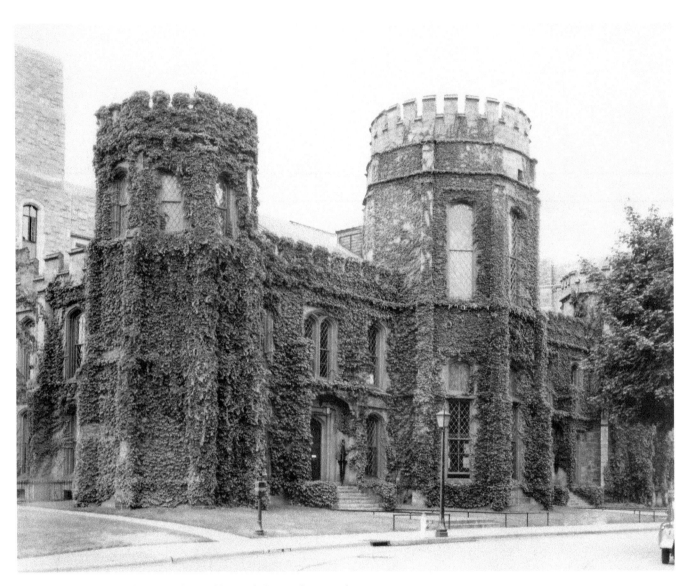

Ivy covers the Cadet Library in this 1944 Signal Corps photograph.

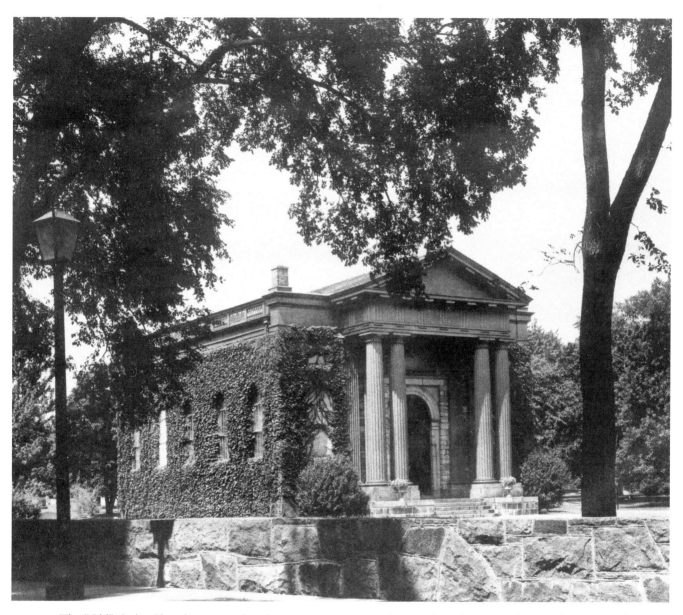

The "Old" Cadet Chapel was moved to the West Point cemetery in 1910 by cadets to save it from demolition. This 1944 photograph shows ivy covering the structure.

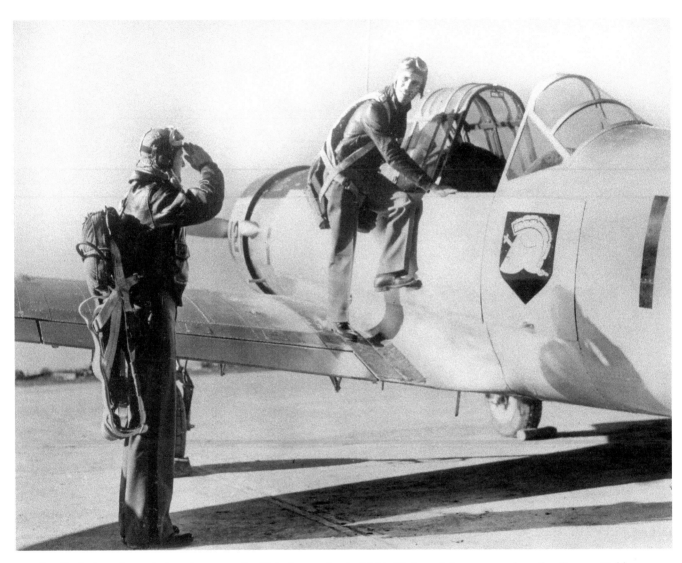

A cadet climbs into the cockpit and prepares for flight instruction in 1944. Flight training was conducted at Stewart Field in Newburgh.

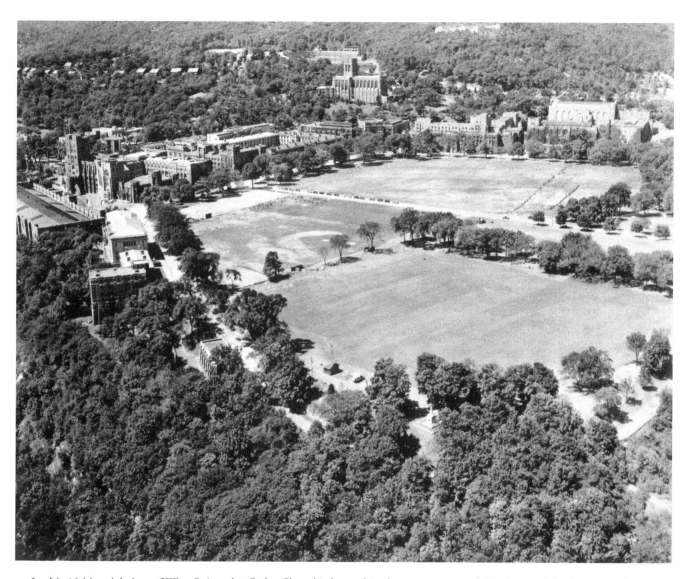

In this 1944 aerial view of West Point, the Cadet Chapel is located in the upper center of the photo, while the gymnasium is on the far right. Starting in the left foreground and progressing toward the background are Lincoln Hall, Cullum Hall, the Officers Club, and Thayer Hall. To the right of Thayer Hall are the Library and Washington Hall.

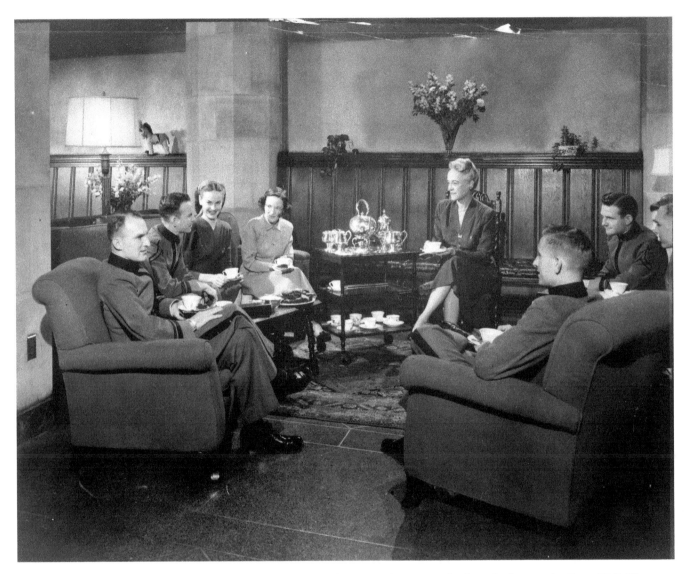

Yearling (second year) cadets and their girlfriends enjoy a leisurely visit with Mrs. Barth, the cadet hostess, in Grant Hall. The cadet hostess was an integral part of the USMA staff and intimately involved with teaching etiquette classes and planning and coordinating social events for cadets and their dates.

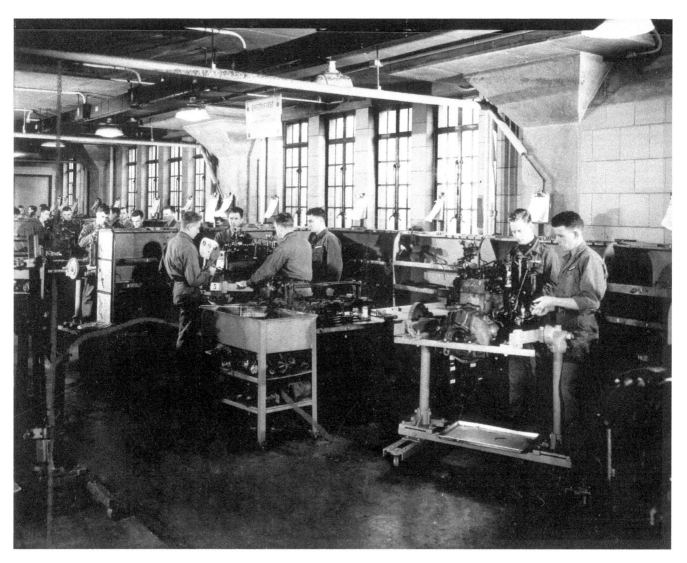

First class cadets are at work in the ordnance lab, intrigued by weapons, motors, and ammunition.

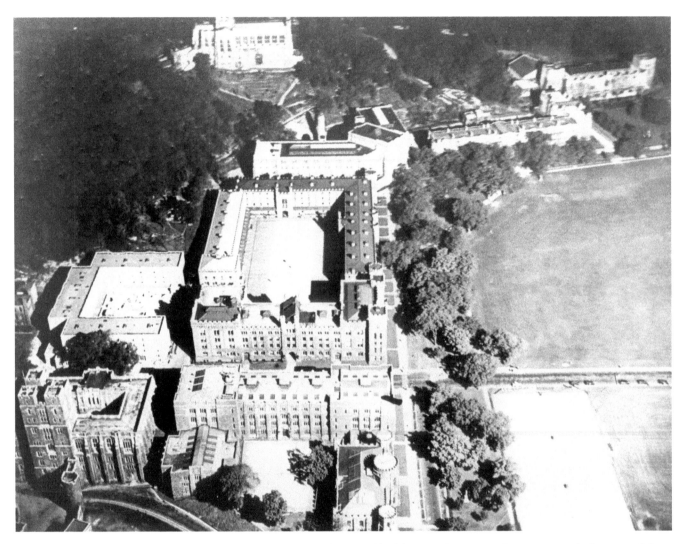

This aerial photo, likely from the 1940s, shows the increasing density of buildings in the twentieth century. At the bottom of the photo is a good view of the old cadet library, which stood for roughly 120 years.

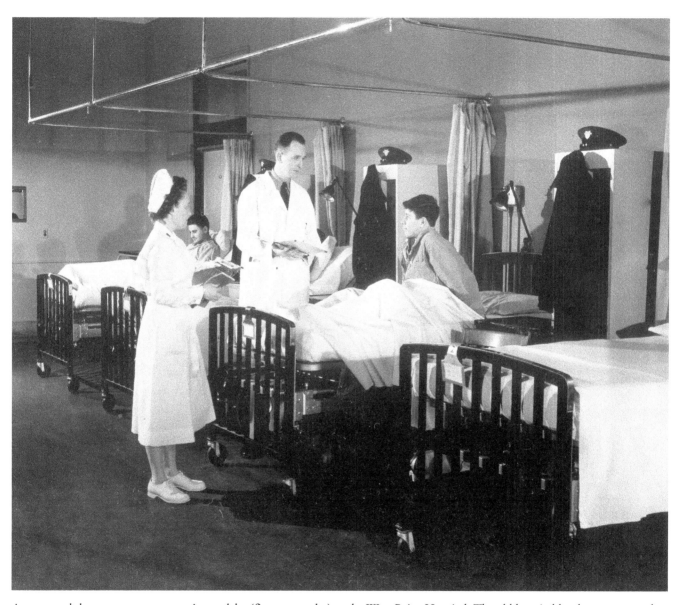

A nurse and doctor prepare to examine a plebe (first year cadet) at the West Point Hospital. The old hospital has been converted to other uses, including a cadet health clinic, optometry clinic, and various other clinics.

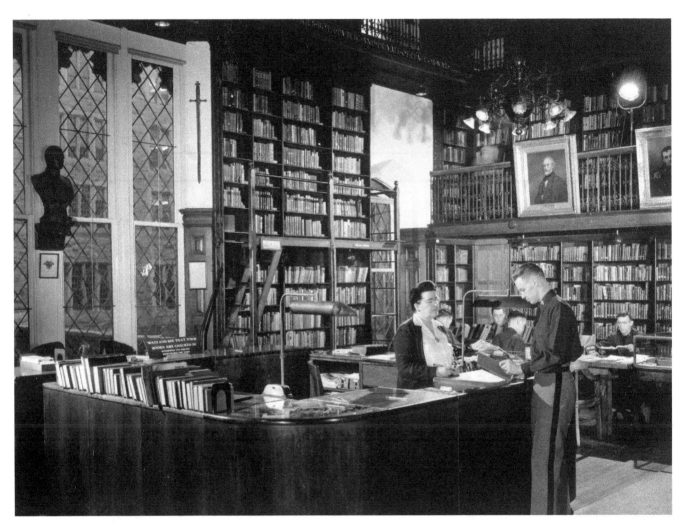

A cadet signs for a book from one of the library staff members at the USMA Library. The Library continues to maintain an exceptional collection of military history books.

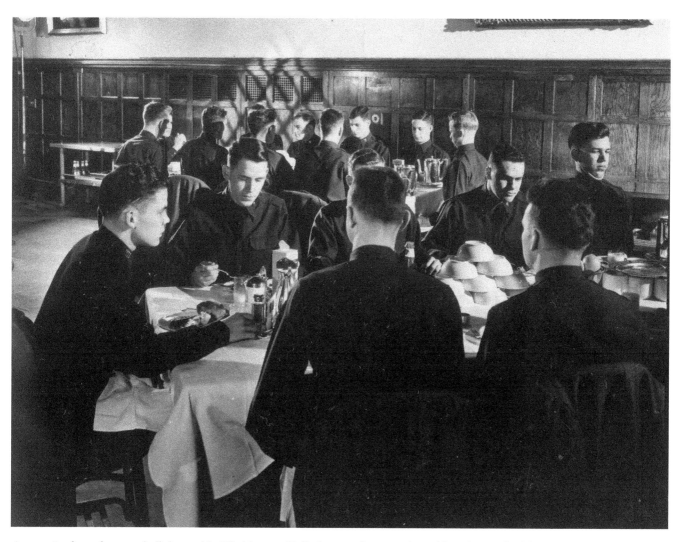

A scene in the cadet mess hall, housed in Washington Hall, shows cadets seated at tables of ten. All of the meals were served family style. The cadet at far-right is a plebe. Fourth classmen at the time and for many years later, were required to sit at a rigid position of attention with their "chin tucked in" and eyes on their plate. Plebes were also required to perform table duties, such as pouring the hot and cold drinks, announcing and cutting the dessert, and passing the empty platters and bowls to the waiters.

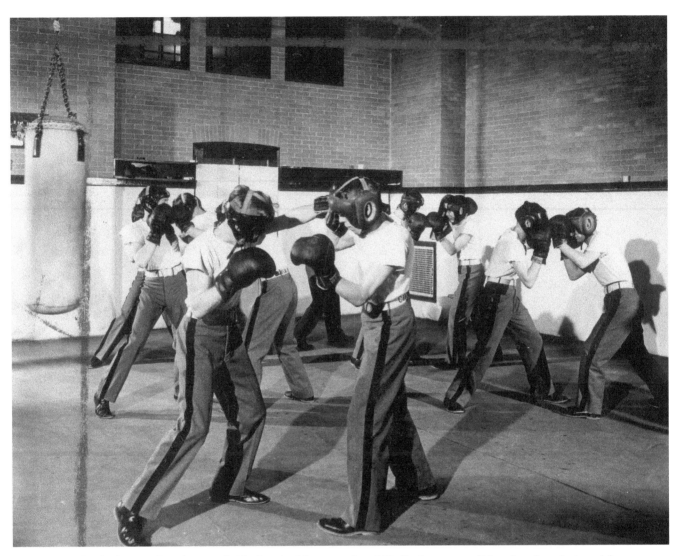

This photo of cadet boxing class shows individuals paired for a sparring drill. Boxing was traditionally taken during plebe year. Cadets are wearing 16-ounce gloves and a headgear and have removed their class shirt, but retained their class trousers and low quarter shoes for the class. Boxing continues to be an integral part of the physical development curriculum and has long been a cadet intramural sport, too. The Academy continues to field an exceptional intercollegiate boxing club.

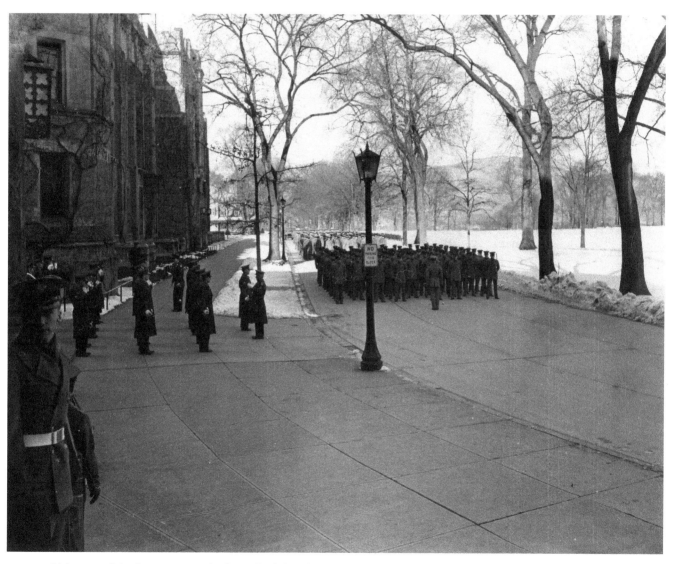

Plebes march in formation on the "apron" of the Plain in this winter scene. The cadet to the left front is sporting the short overcoat, worn with a scarf and gloves. Cadet barracks are to the left.

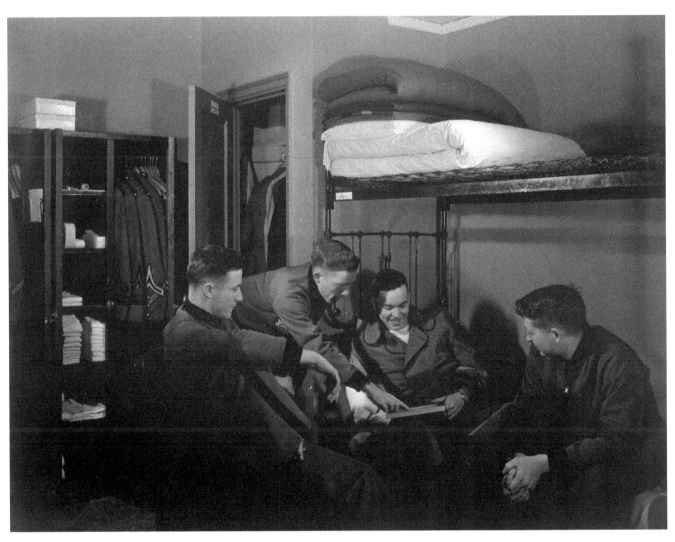

Despite the demanding daily routines, cadets always manage to find time to socialize in the barracks rooms. Beds are arranged in a bunk-bed configuration. Uniforms are neatly hung in the wardrobe to the left.

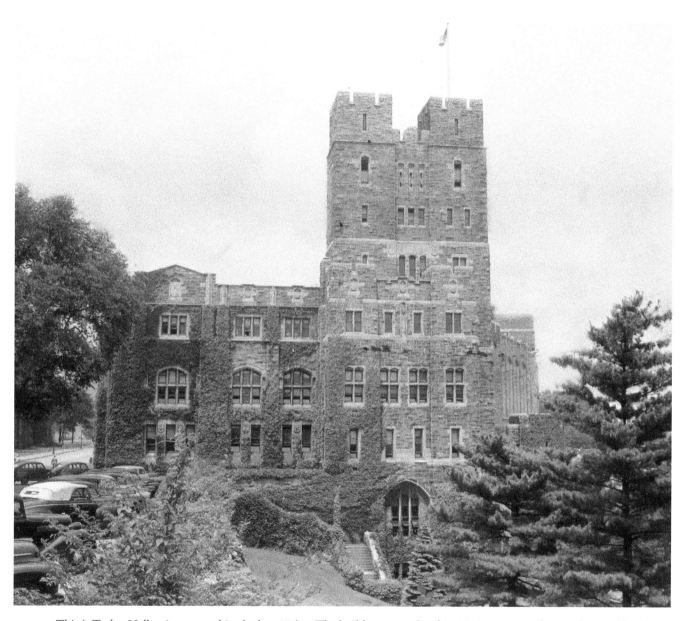

This is Taylor Hall as it appeared in the late 1940s. The building, completed in 1910, was one of many designed by Cram, Goodhue, and Ferguson and features a number of Gothic elements, including a large faux portcullis. The tower rises nearly 158 feet.

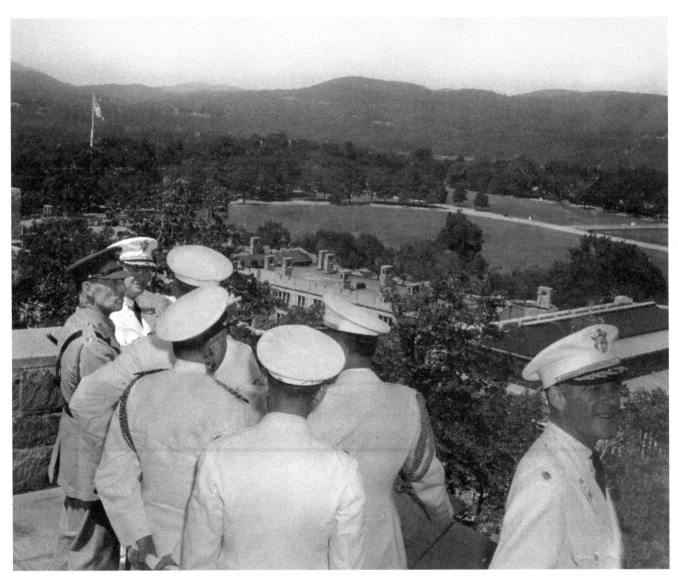

King George II of Greece (1890–1947) views West Point from the Cadet Chapel in 1941. Because of World War II and political turmoil in Greece, the monarch spent much of his reign in exile.

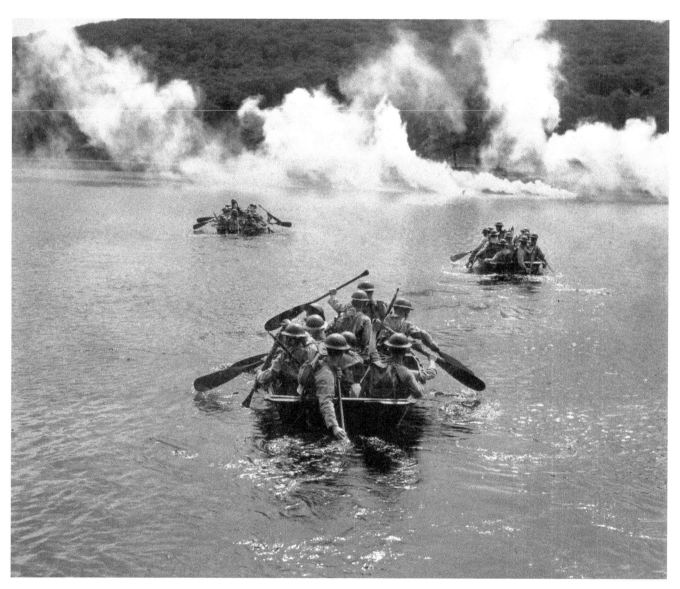

Cadets conduct maneuvers during the summer of 1941.

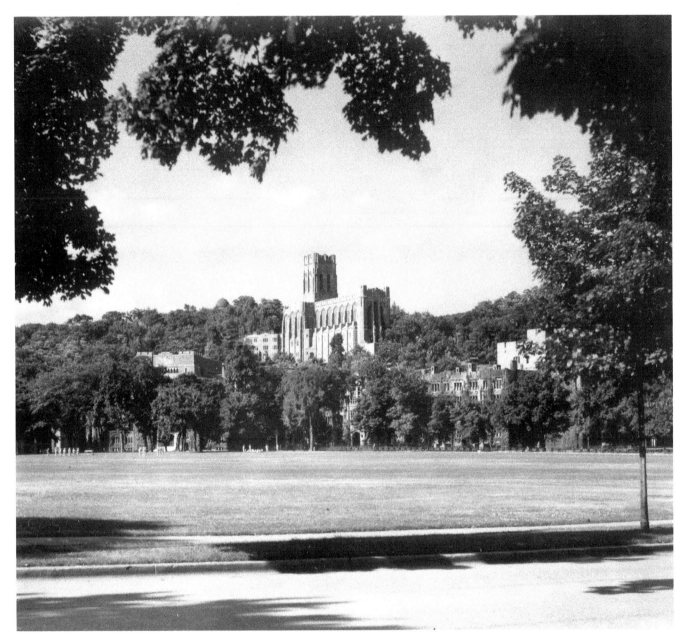

This view of the Plain and Cadet Chapel was recorded in October 1944.

The Shah of Iran, Mohammad Reza Pahlavi, tours West Point on November 23, 1949. As a head of state, the Shah was able to grant "amnesty" to 30 cadets who had violated Academy rules. Just over 30 years later, American hostages seized in Iran after the Shah's overthrow would come to West Point on their trip home after being freed from Iranian captivity.

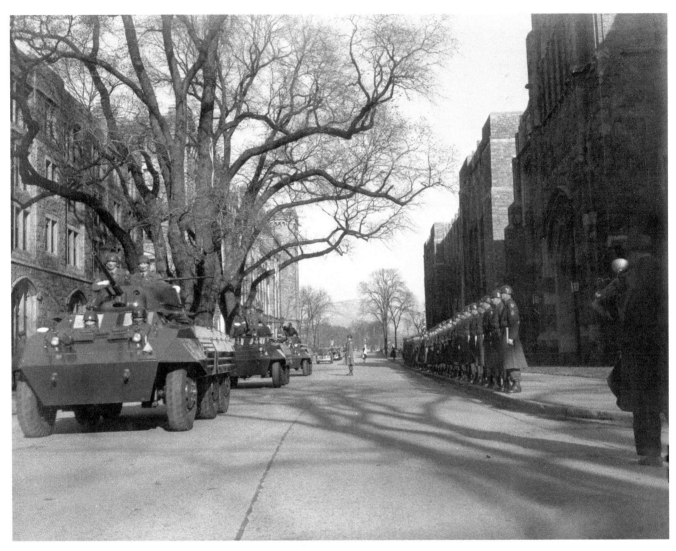

Field Marshal William J. Slim, Chief of the Imperial General Staff of the British Army, visits West Point in December 1949. Although English by birth, Slim eventually became an officer in the British Indian Army. He fought in World War I, where he was wounded at Gallipoli, and in World War II, where he led British forces against the Japanese in Burma. He later became governor-general of Australia.

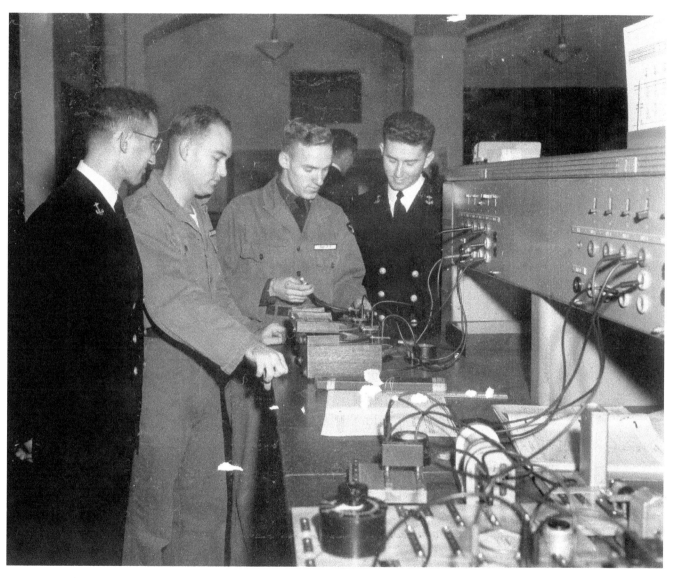

United States Military Academy Cadets and USNA Midshipmen examine the characteristics of photoelectric cells during an electrical engineering class in 1951.

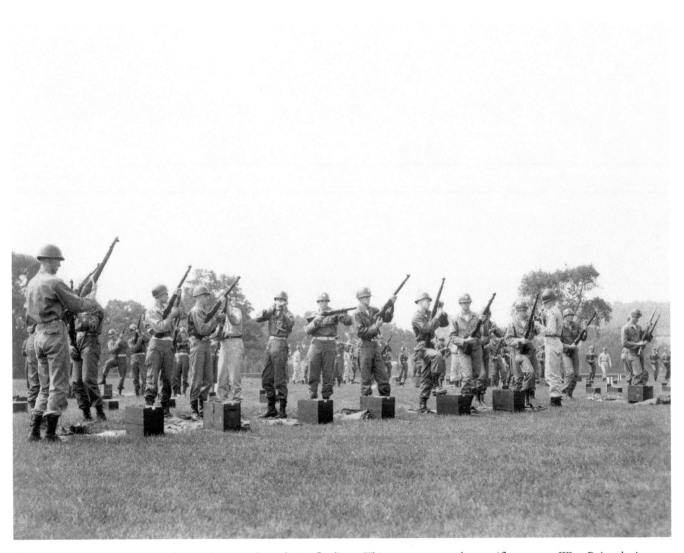

Upperclassmen instruct new cadets on how to adjust their rifle slings. This scene occurred on a rifle range at West Point during summer training about 1951.

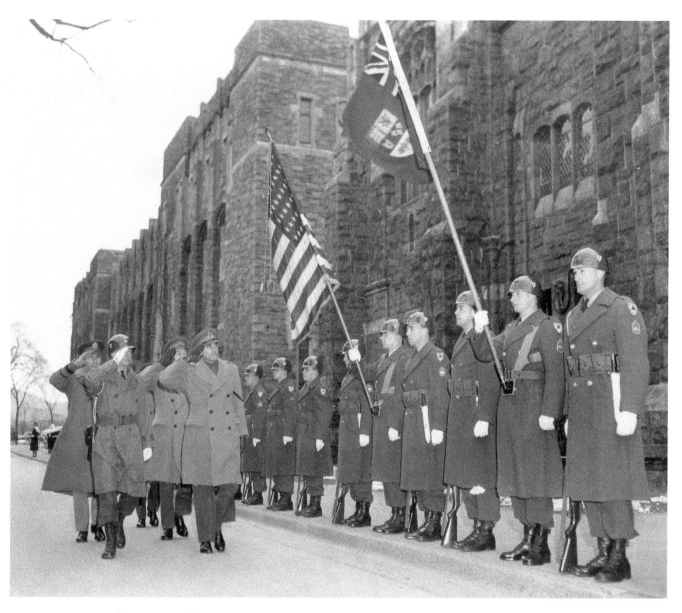

Lieutenant General Guy Greenville Simonds, Canadian Chief of the General Staff, inspects the Honor Guard in 1951. Simonds led Allied forces to victory in Belgium and the Netherlands during the Battle of the Scheldt in 1944.

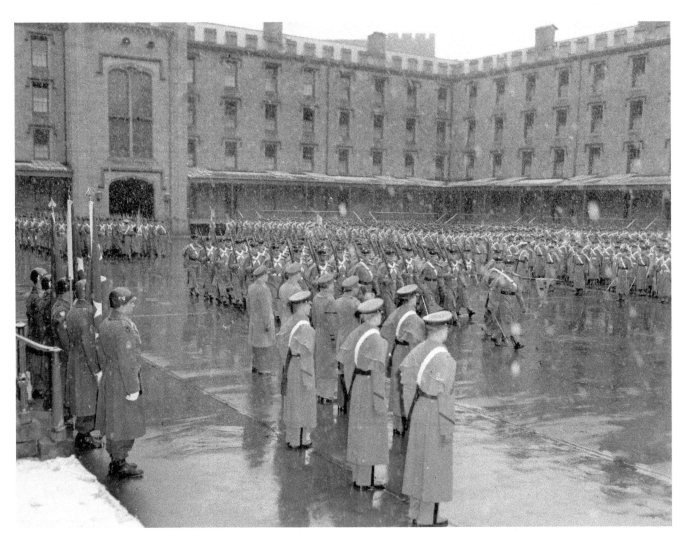

Cadets appear in formation during the visit of Canadian general Guy Simonds, 1951.

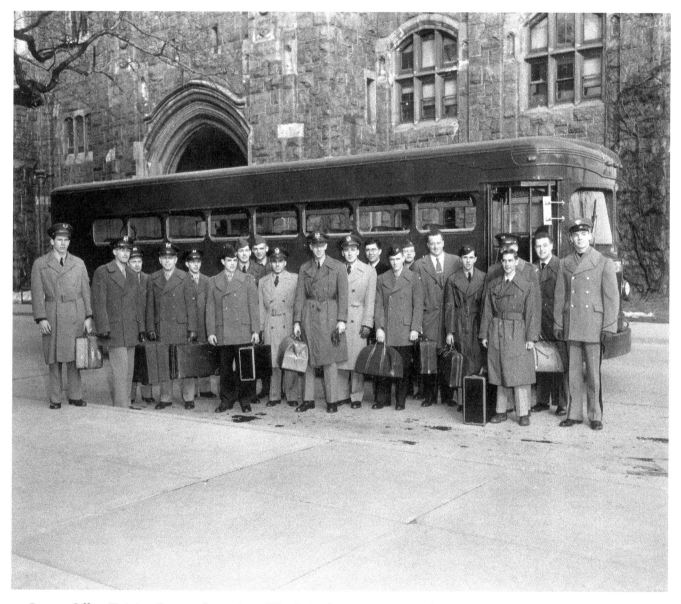

Reserve Officer Training Corps cadets arrive at West Point for a visit in 1952. This group was part of a larger contingent of 110 students visiting USMA on that day. During the course of the Academy's Sesquicentennial year, more than 440 ROTC cadets visited West Point.

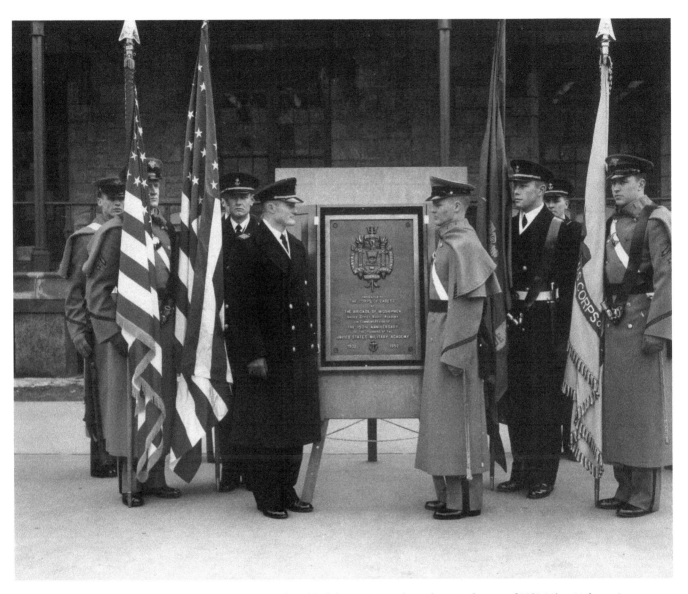

Midshipman Robert McDonald presents a plaque on behalf of the U.S. Naval Academy in honor of USMA's 150th anniversary. Accepting the plaque is the Cadet First Captain, Gordon Carpenter, 1952.

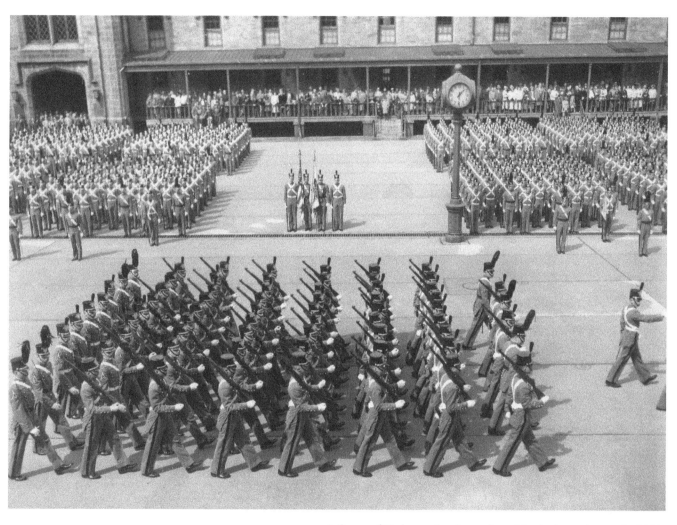

A Corps of Cadets review is conducted in the barracks area in 1952.

Notes on the Photographs

These notes, listed by page number, attempt to include all aspects known of the photographs. Each of the photographs is identified by the page number, a title or description, photographer and collection, archive, and call or box number when applicable. Although every attempt was made to collect all data, in some cases complete data may have been unavailable due to the age and condition of some of the photographs and records.

32 STUDY PERIOD
United States
Military Academy
at West Point
0389

33 CHANGING OF
THE GUARD
National Archives
55569

34 MOVING
ARTILLERY
National Archives
55556

35 MARKSMANSHIP
CLASS
National Archives
55565

36 TECHNICAL
DRAFTING
CLASS
United States
Military Academy
at West Point
0406

37 CELEBRATION
United States
Military Academy
at West Point
0690

38 CREW DRILL
National Archives
55562

39 COAST
ARTILLERY
GUNS
National Archives
55559

40 CADET CHAPEL
CORNERSTONE,
1909
National Archives
0665

41 CADETS
PARADING
National Archives
55582

42 INSPECTION
National Archives
55581

43 POLO
National Archives
55567

44 OPEN-AIR RINK
National Archives
55568

45 NORTH
BARRACKS
National Archives
55930

46 PACKING
MULES, 1910
National Archives
55571

47 CAVALRY
OPERATIONS
National Archives
55923

48 FORTIFYING
TRENCHES
National Archives
55935

49 SWEARING-IN
CEREMONY,
1913
United States
Military Academy
at West Point
0952

50 AVIATION
DEMONSTRATION
National Archives
5552

51 CHEMISTRY
LESSON
National Archives
55296

52 UNIFORMS OF
THE TIMES
National Archives
55535

53 RECEPTION DAY
National Archives
90363

54 CADETS
MARCHING
National Archives
90326

55 CLEAN
BARRACKS
National Archives
55920

56 FIELD
TELEPHONE
National Archives
55933

57 CONSTRUCTING
GABIONS
National Archives
55936

58 PONTOON BOAT
National Archives
90312

59 PONTOON
BRIDGE
National Archives
55548

60 DRAWING
CLASS
National Archives
55928

61 CADETS
RESTING
National Archives
90401

62 TENT CITY
National Archives
55922

63 PONTOON
BRIDGE
CONSTRUCTION,
1918
National Archives
55544

64 LIVE-FIRE
TRAINING
National Archives
90319

65 FIRING
ARTILLERY GUN
National Archives
90335

66 FIRING
IN PRONE
POSITION
National Archives
90331

68 BATTLE
MONUMENT
National Archives
56807

69 SECRETARY OF
WAR BAKER
National Archives
56797

70 GRADUATING
CLASS, 1919
National Archives
60915

71 BOARDING
LEVIATHAN
National Archives
60917

72 ARMY FOOT
MARCH
National Archives
90324

73 MACHINE GUN
TRAINING
National Archives
90333

74 FIELD
TELEPHONE
National Archives
90305

75 FORMING UP
National Archives
90367

76 HORSE SHOW
National Archives
1172b

77 CAMP SMITH
MESS TENT
National Archives
90325

78 FIELD TRAINING
EXERCISE
National Archives
90322

79 TAKING BOARDS
National Archives
90404

80 MEDAL
CEREMONY
National Archives
90408

Printed in the USA
CPSIA information can be obtained
at www.ICGtesting.com
JSHW072026140824
68134JS00042B/3802